Mary Engelbreit
The Art and the Artist

Other Books by Mary Engelbreit

Believe: A Christmas Treasury
Christmas with Mary Engelbreit: Let the Merrymaking Begin
Happy to You! It's Your Birthday
Mother O'Mine: A Mother's Treasury
My Symphony
The Snow Queen
Poster Book: Classic Collection
Something to Do Children's Activity Book Series
This Woman Deserves a Party
Time for Tea
Tiny Teeny Halloweeny Treasury: A Halloween Treasury
The Wit and Whimsy of Mary Engelbreit
Words to Live By Gift Book Series

Cookbook Series
Cookies
Dining Out
Let's Party
The Queen of the Kitchen Cookbook and Journal
Sweet Treats
'Tis the Season Holiday Cookbook

Craft Books
Spring • Summer • Autumn • Winter

Companion Series
Mary Engelbreit's Home Companion • Children's Companion •
Christmas Companion • Outdoor Companion

Home Companion Magazine Book Series
Collections • Fabric • Paint • Plates
Leading the Artful Life

Mary Engelbreit
The Art and the Artist

by Patrick Regan
with Mary Engelbreit

**Andrews McMeel
Publishing**

Kansas City

MARY ENGELBREIT

Mary Engelbreit: The Art and the Artist copyright © 1996, 2002 by Mary Engelbreit Ink. All rights reserved. Printed in China. No part of this book may be used or reproduced in any manner whatsoever without written permission except in the case of reprints in the context of reviews. For information, write Andrews McMeel Publishing, 4520 Main Street, Kansas City, Missouri 64111.

Photographs on pages 86, 87 copyright © Barbara Elliott Martin.

A hardcover edition of this book was published in 1996 by Andrews McMeel Publishing.

and Mary Engelbreit are registered trademarks of Mary Engelbreit Enterprises, Inc.

10 9 8 7 6 5 4 3 2 1 ELE 06 05 04 03 02

Library of Congress Cataloging-in-Publication Data as Cataloged for the Hardcover Edition
Regan, Patrick, 1966-
 Mary Engelbreit : the art and the artist / by Patrick Regan ; with
Mary Engelbreit.
 p. cm.
 ISBN 0-8362-2232-6 (hardbound)
 1. Engelbreit, Mary. 2. Illustrators--United States--Biography.
3. Engelbreit, Mary--Criticism and interpretation. I. Engelbreit,
Mary. II. Title.
NC975.5.E54R44 1996
741.6'092--dc20
[B] 96-27014
 CIP

ISBN 0-7407-2081-3 (paperback)

Design by Stephanie Raaf

ATTENTION: SCHOOLS AND BUSINESSES

Andrews McMeel books are available at quantity discounts with bulk purchase for educational, business, or sales promotional use. For information, please write to: Special Sales Department, Andrews McMeel Publishing, 4520 Main Street, Kansas City, Missouri 64111.

Preface

It's been five years and several print-runs since *Mary Engelbreit: The Art and the Artist* was first published. Amazingly, given the level of success she'd already reached at that time, the past five years have seen the greatest growth in her company's history. Mary's is a cottage industry gone global. A best-selling calendar program, a bi-monthly décor and lifestyle magazine, more than 150 book titles in print, 25,000 domestic and international retailers including her own store—all of it adds up to what the *Wall Street Journal* has called a "vast empire of cuteness."

Honors and accolades have followed along with the commercial success. She was selected to create art for the 2000 White House Easter Egg Roll and the 2002 Olympic Winter Games, and recently Mary Engelbreit was named "Best Art License of the Year" by the Licensing Industry Merchandisers' Association.

Mary's even prouder of another accomplishment. Her company has recently launched a partnership with First Book, a nonprofit organization that delivers new books to low-income children. Her involvement was a key factor in enabling the organization to deliver two million books to kids in the last year alone.

But in spite of all the changes and achievement, what's perhaps more remarkable is what hasn't changed. Mary Engelbreit herself continues to create, by her hand alone, illustrations that have an uncanny knack for reaching an intimate place in the hearts of an ever-growing audience. Her art still makes people stop, smile, and remember that there's lots of good in this old world, and, in fact, it surrounds us every day.

For Mary—at least as far as the art is concerned—not all that much has changed since she was a single-minded little girl who decided at age 10 that she simply had to be an artist. She is doing what she loves to do. Doing what comes naturally. That same little girl still sits at the core of this bustling business, grown up now, but still drawing her pictures with the same sense of wonder, imagination, and enthusiasm. Some things will never change.

Patrick Regan
September 2001

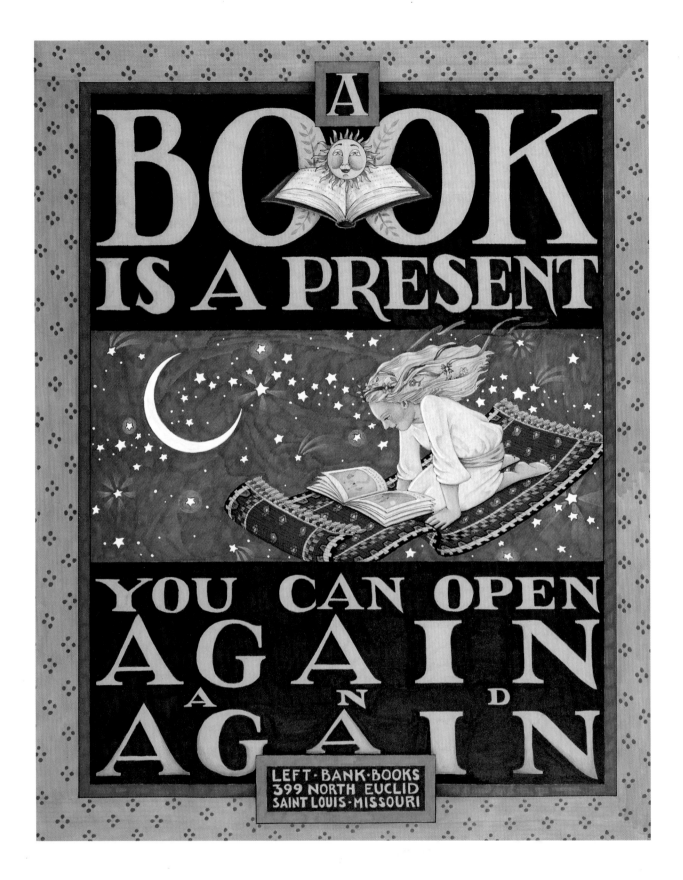

Contents

For my mother,
who always told me
anything was possible.

Grateful Appreciation

Alexa and Steve Anderson

David Bari

Debby Busch

Mary Lois Engelbreit

Katie Gurley

Anene Hauschultz

Helen and George Kennedy

Ladd Leavens

Left Bank Books

Jean Lowe

Charlotte and Andrew Lyons

Ann McKendry-Kutz

Barbara Elliott Martin

Missouri Historical Society

Terri and Joel Pesapane

Margaret and Martin Quigley

Stephanie Raaf

Jack Ripley

Saint Louis Art Museum

Saint Louis Post-Dispatch

The Salvation Army

Audrey and Robert Whalen

introduction

The Queen of Everything

The first thing to understand about Mary Engelbreit is this: She is *real*. She exists—not as a brand name invented by a savvy greeting card company and not as an alias for a group of artists who've perfected a unified aesthetic style. Mary Engelbreit is a living, working artist, and she's as real as people get.

"A lot of people are very surprised to learn that," says Mary with an easy smile. "They think it's like Aunt Jemima or Betty Crocker. Actually, I think there was a Betty Crocker." (Indeed, she second-guesses herself just like a real person.) "A lot of people don't really think I'm a person."

But *Mary Engelbreit?* Isn't the name almost too cute? Almost too felicitous? Well, *it's* real, too; as real as it was when her great-grandparents brought it to America from Germany. "I don't think it sounds like a made-up name," the artist defends. And as a veteran of uncountable autograph sessions and personal appearances, she reasons, "Why would I make up such a long name?"

Mary Engelbreit is real and lives in a suburb of St. Louis, Missouri, with her husband Phil Delano, who helps run The Mary Engelbreit Company, their two sons, Evan and Will, two cats, and two dogs. True to Engelbreit color ways, her pets, while not checkered, are black and white. She has been an illustrator all of her working life and began publishing her enormously popular greeting cards in the late 1970s.

Mary was born less than ten miles from where she lives and works today. She never left St. Louis to find greatness.

1

Her greatness has been such that plenty of people have been willing to look for it, and with ever-increasing frequency, they find it. They find Mary's work not only on greeting cards but also on hundreds of other products, including gift wrap and doormats, dinner plates and shower curtains, bookmarks and button covers, cotton throw rugs and ceramic mugs, jigsaw puzzles, umbrellas, and even musical picture frames.

The ultimate source of this huge body of work is Mary Engelbreit herself. She has help, to be sure—lots of it. She has, in fact, grown into an industry with an Inc., or more accurately and appropriately, an INK after her name. But Mary herself hatches every concept in her head and draws every original piece of art with her hand. The help comes later, when it is time to apply her work to the myriad products on which it appears. Her lead designer, Stephanie Barken, calls what the small staff does "reformatting." "The border art from a greeting card illustration will become the pattern on a gift bag," she says by way of example. "But we don't create anything new. All of this is Mary Engelbreit art."

Know Mary's art, and you know a good part, but not all, of Mary herself—thoughtful, but never self-absorbed; kind, but not coddling; original, yet comfortably familiar; timeless, but also timely. As is the art, so is the artist—shy, but not always quiet; charming, but sneakily substantial; nurturing, as only a mother can be; modest, but accepting of her talents—and aware of her shortcomings, too. Most of all, as one of her longest tenured employees puts it, "Mary is a regular person. Mary is just Mary."

Getting to know the real Mary Engelbreit and getting to know her artwork are inseparable endeavors, and they are what this book is all about. In it, Mary tells you how she taught herself to draw and gradually built her career as an illustrator. She addresses often-asked question like, "Where do you get your ideas?" and explains the creative process involved in producing her endearing and enduring illustrations. Family, friends, and people who work with Mary every day talk about Mary and her artwork. In addition, an amazing array of Mary's art, from grade school scribblings

to reproductions of her most famous illustrations, speaks for itself. This book contains the largest, most extensive collection of Mary Engelbreit's work ever published. It represents nearly forty years of Mary's art (lest you overestimate her age, Mary drew her earliest surviving picture at age four) and includes many drawings never before reproduced or seen by the public.

Mary's artwork doesn't attract casual buyers. It attracts converts. Her art wins hearts. She has made icons of teapots and straw hats. She has made stars of spunky little girls and cottage roses. Even the most pedestrian items, like mixing bowls and watering cans, ascend to heroic stature once they receive the Engelbreit treatment.

In a classification-crazy world, Mary's illustration style is most often pegged "cute," "nostalgic," and "whimsical." All are accurate descriptions, but none complete. Magic intangibles breathe life into Mary's work. Love, trust, faith, esteem, and spirit are a few of them. For the real story of what gives Mary's work its magic, it helps to look a little bit deeper into her art and her life. Her story began in 1952.

Know Mary's art,
and you know a
good part, but not all,
of Mary herself—
thoughtful, but never
self-absorbed; kind,
but not coddling;
original, yet
comfortably familiar;
timeless,
but also timely.
As is the art,
so is the artist.

The real voyage of discovery consists
not in seeking new landscapes
but in having new eyes.
—*Marcel Proust*

Home Is Where One Starts From

Mary Engelbreit's earliest surviving artwork hangs framed on the wall outside her St. Louis studio. The subject: two stick figures holding hands. The medium: crayon, of course. Written above the drawing in a mother's proud hand are the words, Drawn by Mary on November 27, 1956: A picture of Mommy and Papa.

"She was drawing from the time she could pick up a pencil," recalls her mother.

Kids love to draw, and in this way Mary was unremarkable. Her childhood pictures would be at home in any kindergarten gallery. She was never a technical prodigy. But even as a child, Mary seemed to have *something* that set her apart—something, perhaps, in her eyes and the way she used them.

Mary got glasses in the second grade.
I'll never forget that day.
I had had my wisdom teeth pulled,
and I was lying in bed
with my jaws aching.
She came in with these glasses on.
I looked at her and I cried,
which, I guess,
wasn't a very nice thing to do.
—Mary Lois Engelbreit

But seven-year-old Mary was oblivious to her mother's momentary lapse in composure. The newly bespectacled second-grader was caught up in emotions of her own. "Mother, the trees have leaves!" Mary remembers saying in awe of the world's new clarity. "I was amazed. The whole world was brought into focus, and I hadn't even known that

"I told my parents when I was eleven that I wanted to be an artist, and I never wavered."

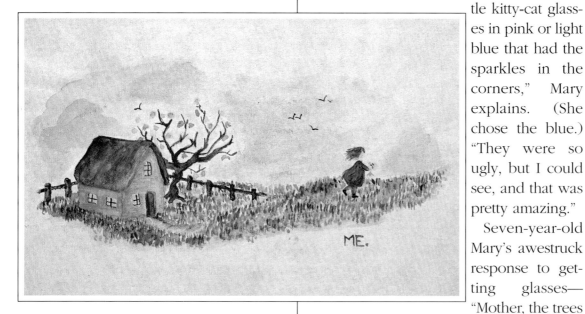

it was out of focus."

"She didn't know that trees looked the way they looked," recalls Mary's mother. "She was so thrilled that she could see. I cried because she had to wear glasses, which was stupid, but she didn't mind."

Well, to hear Mary tell the story, she *did* mind. She loved the clear vision, but she *hated* the glasses. "Back then, all you could get if you were a girl were little kitty-cat glasses in pink or light blue that had the sparkles in the corners," Mary explains. (She chose the blue.) "They were so ugly, but I could see, and that was pretty amazing."

Seven-year-old Mary's awestruck response to getting glasses—"Mother, the trees have leaves"—is telling. And it may do more to presage her future than any crayon-on-Big-Chief-artwork she produced as a child. Her vision had changed, and she saw a new world.

Mary was eleven when she encountered her first "real" artist. A real artist,

she quickly ascertained, had a studio. "One of the baby-sitters in our neighborhood was a really good artist, and she had a studio set up in her basement," recalls Mary. "I can't tell you how impressed I was. I was insanely jealous of this cool thing, and I went home and told my mother about it. I said, 'I just have to have one. I have to have a studio.' So she cleared out the linen closet."

The vacuum, mops, and towels came out, and Mary's supplies—a desk, a chair, and a pen-and-ink set—moved in. "We jammed all this furniture in there for me," she remembers with a laugh. "I'm sure it was about 110 degrees, but I happily sat in there, in the closet, and drew pictures."

This may have been the most obvious first step in Mary's independent, artistic development, but long before she moved into her first "studio," Mary had discovered that the act of drawing held an unmatchable allure. She simply loved to draw. And though she didn't realize it at the time, her apprenticeship was coming at the hands of some largely forgotten giants of the illustration world.

In Mary's preschool and early grammar school years, her mother (referred to here by her full name, Mary Lois, for the sake of clarity) would read to Mary

By the time Mary painted this watercolor in grade school, she had already adopted her familiar "ME" signature.

and her younger sister, Alexa, every night. Mary Lois had an affinity for the lavishly illustrated storybooks that her own mother had read to her as a child and had preserved a large collection of her favorites. In a fortunate coincidence that would profoundly affect her oldest daughter's future, Mary Lois largely ignored popular children's books of the day in favor of the timeworn but beloved books of her own childhood.

It was obvious from the start that Mary shared her mother's enthusiasm for the old books. But Mary's mother soon grew to suspect that it wasn't always the rhyme or story that held her oldest daughter's interest. "I read to the girls every night," she remembers. "Every once in a while, Alexa would say that she was going to watch television, but Mary always stayed for the read. She loved the stories, but I think mainly she liked the pictures."

"They were different from anything that was being put out in the 1950s," explains Mary's mother of the vintage books. "They were old-fashioned looking. Mary always liked the old ones—the same way she likes old pictures of people. She has all kinds of old photographs of our relatives: my grandparents, her father's grandparents, Phil's family . . . old pictures. I guess she liked that from the beginning."

7

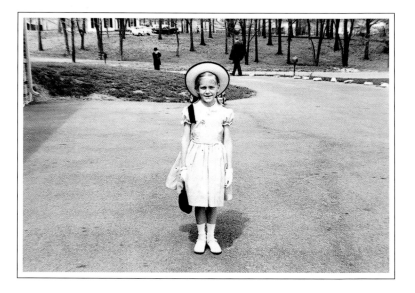

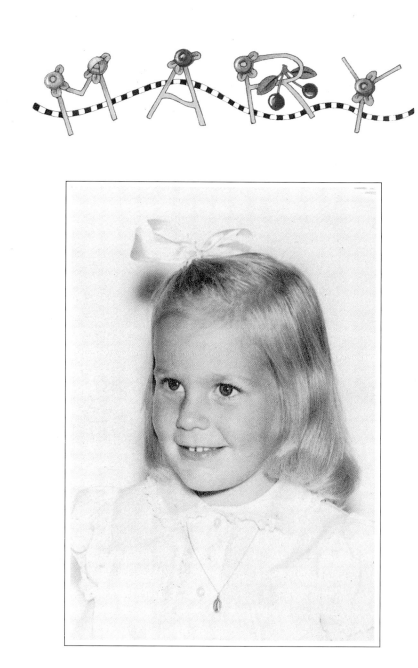

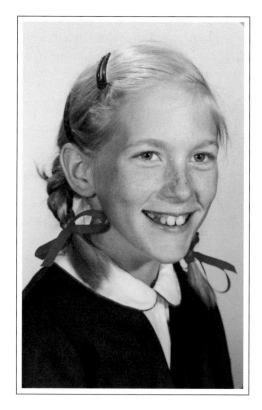

Portraits of the artist as a young girl.
(Clockwise from above)
Angelic at age four;
modeling her Easter outfit at age seven;
fourth-grade school picture, age 9.

"Engelbreit" was way too long to write out, so I used my initials instead.
—ME

Mary liked the pictures in the antique storybooks so much, in fact, that she began to copy them. She'd spend countless hours with her mother's Raggedy Ann and Andy books, recreating the colorful, loosely rendered drawings by famed illustrator Johnny Gruelle. At other times she'd imitate the softer, more painterly style of artist Jessie Wilcox Smith, whose illustrations decorated many of the other vintage storybooks.

From these early-twentieth-century illustrators, Mary also picked up a habit that quickly became her artwork's stamp of authenticity. Many of the artists she emulated enclosed their signatures in boxes or circles, she explains. "So, I did it too. Engelbreit was way too long to write out, so I used my initials instead." The fact that her initials spell *me* is a pleasant coincidence and fitting for a woman who puts so much of herself into every drawing that she creates.

Young Mary even turned television viewing into artistic training as she copied characters from Popeye cartoons. "I also had the John Gnagy Learn To Draw kit," she says with a smile. "He was on TV every Saturday morning, and I would watch religiously. I would follow along with him and do all the lessons."

Her sister Alexa was occupied with her own childhood pursuits. Her parents were inclined to let their oldest daughter do what kept her happy, busy, and quiet. And Mary, in those often solitary hours, was teaching herself to draw.

"Mary's all-time dream was to illustrate children's books," her mother remembers. "That's what she talked about all the time. She just loved to look at those old books. She could envision those fairy tales coming to life."

Before too long, Mary's imagination began to carry her beyond the worlds created by the minds and pens of others. Naturally and instinctively, she moved from *re*-creating to creating. "I taught myself to draw by copying," she explains, "but if you do that long enough, you start drawing your own little people."

In childhood, recurrent themes and characters often sprang from Mary's pen. One of the first "little people" to emerge has become synonymous with her work and, to many of her fans, synonymous with Mary herself. "The girl with the glasses in the hat and sailor suit," Mary says. "I've been drawing her in one form or another since I was little, around ten or eleven."

As the only recurring character in Engelbreit's universe, the little girl with hat and glasses is the only figure to be honored with a name. Mary calls her Ann Estelle, after her grandmother on her mother's side. But while the name may be her grandmother's, the physical characteristics, audacious attitude, and quick wit are pure Mary. To those who know Mary and her work well, there's no doubt about who Ann Estelle really is.

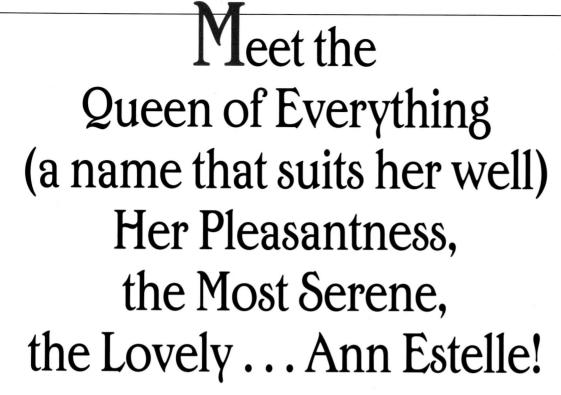

Meet the
Queen of Everything
(a name that suits her well)
Her Pleasantness,
the Most Serene,
the Lovely . . . Ann Estelle!

Mary Engelbreit's illustrations depict childhood as a carefree time when best friends are made, promises are kept, and there is always time to dream. Her illustrations reflect the childhood she thinks every kid deserves, a childhood not too far removed from what she experienced growing up in a suburb of St. Louis.

Occasionally, a critic will charge that Mary's work is overly idealistic. "Some people think my artwork is a little too sweet," Mary admits. "They just flat out don't believe it, but what I draw is taken from my life. I had a fantastic time as a kid. I had a great family, and we lived in a fun neighborhood. A lot of people talk about how awful their childhoods were, and I feel so bad for them. I honestly had a wonderful childhood."

With adulthood, Mary admits, comes cynicism, but she tries to retain a child's innocence in her art. "When you're a kid, you don't see a lot of the negative stuff," she says. "I led a very protected, sheltered life, and I'm glad I did. I can't see anything wrong with that. I think it's a shame that kids today are exposed to so many hideous things. So, to people who say, 'You're drawing an idealized world where you'd like to live,' I say, 'Of course I am. What's wrong with that? Don't you wish you lived there, too?'"

Mary is the oldest of three sisters. Her youngest sister, Peggy, was born ten years after Mary, but only two years separate Mary and her middle sister, Alexa. The two older sisters grew up best friends and roommates. Together, they rode bikes and played in the woods, the creek, and later the construction sites that surrounded their suburban home. They played school in a little room their father built in the basement. Mary played teacher and all the other traditional big-sister roles. "I used to follow her around all the time," the younger sister says. "She was the leader in our family."

According to Alexa, her older sister hasn't changed much since they were kids. "She's always been headstrong . . . always been honest," Alexa says. "She's very opinionated, just like my mother. She has her own beliefs, and she sticks to her guns."

Mary's mother remembers her eldest daughter as a willful child, "full of old-fashioned stick-to-itiveness." Mary is a little less charitable in describing herself as a girl. "I was bossy," she says with a laugh, admitting that the trait would later win her the well-known title: the Queen of Everything.

Although reading and drawing were always her overriding passions, Mary wasn't the type of child who practiced violin while the other kids played outside. "I was right in there—in the action with the rest of the kids," she says. "I did spend a lot of time alone—reading, drawing, or playing with the dollhouse my father made me, and I liked to be alone. It didn't bother me at all. But we also had a lot of kids in the neighborhood, and as I look back, I'm sure they all thought I was obnoxious. I was always the one directing everything, but we had a lot of fun."

Like her love of drawing, Mary's penchant for decorating and design surfaced at an early age. "My mother and I were always redecorating the house," she says. "My sisters didn't care about that at all, but Mom and I were always rearranging the furniture, and we'd go out and look at wallpaper for hours at a time."

Antique shopping was another passion shared by mother and daughter. Even today, Mary Lois will often receive a call from her daughter saying "I need a fix—let's go shopping."

Prowling antique stores together, they don't always agree on what constitutes a great find. Their difference in perspectives dates back to Mary's earliest purchases. "I collect baby plates," says the illustrator. "I bought the first one when I was twelve, at a flea market. I bought that plate because I loved the drawing on it. And I remember my mother saying to my father, 'Do you see the stuff that this child picks out?' She thought they were odd things for a kid that age to want, but she definitely encouraged it. A lot of the collections I have now,

I started when I was a little girl."

"She buys things that I remember from my childhood, which was the '30s," her mother explains. "She'll say, 'Isn't this darling?' and I'll say, 'No, I think it's horrible. I didn't like it then, and I don't like it now.' But she just loves that period."

Mary doesn't exactly know why, but she admits to having a weakness for products from the '20s and '30s, and not just for children's books and baby plates—her fondness for the period extends to architecture, furniture design, and especially toys.

When Mary's on a junk-store junket, antique toys are among her favorite quarry. She's drawn to the old toys, she says, for the same reasons she favors antique books. "Great design, great color. They're just very friendly looking. They're not overdesigned to within an inch of their lives," she says. "Now things are mass produced. I think part of the charm of the older stuff is that it's closer to being handmade. It's a little more personal—a little more human."

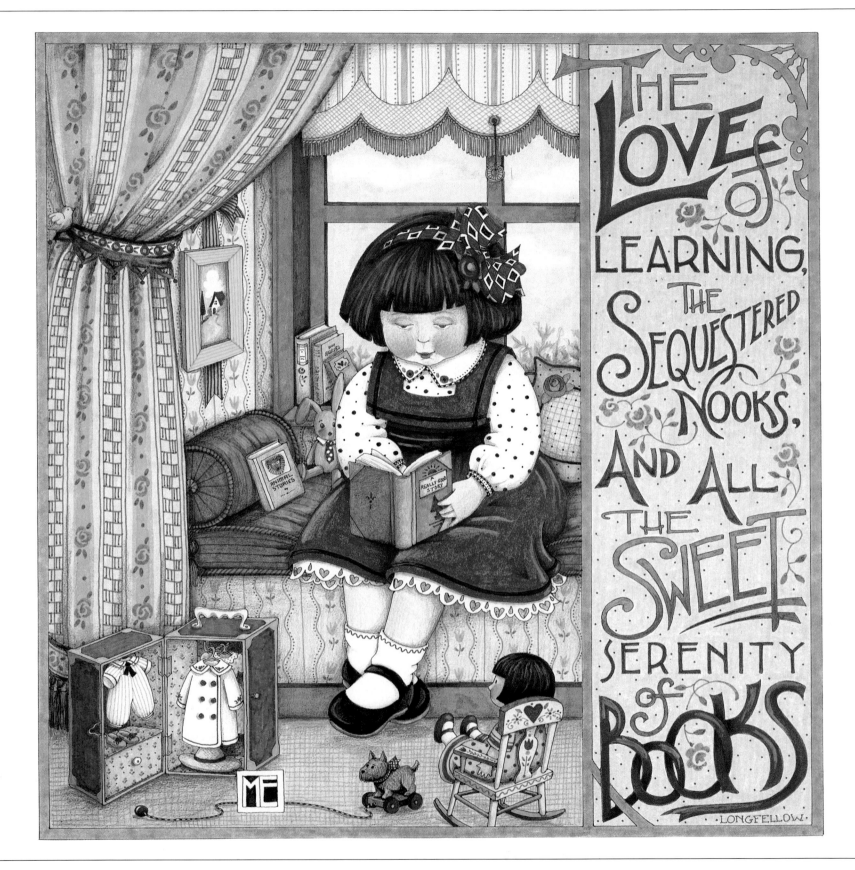

THE LOVE of LEARNING, THE SEQUESTERED NOOKS, AND ALL THE SWEET SERENITY of BOOKS

LONGFELLOW.

Mary has always been a voracious reader. According to her husband, she often goes through three to five books a week. As a child, reading and drawing proved to be highly symbiotic activities. "I loved to read, and I would draw pictures to go with the stories I read," she explains. "That's really why I started drawing."

Among her favorite books were *The Secret Garden, Jane Eyre, The Little Princess*, and the Nancy Drew series. "All those 'girl books' mostly," she says, "but I'd read anything." When she set down a book, she'd pick up her pen. "I wouldn't necessarily draw a scene from the book, but I would draw a girl dressed like the girls in the book," she says. "I would draw little scenes from that time."

Her illustrating supplies were minimal. By the time she'd set up her linen closet studio, she had foregone crayons for a more professional medium. "All I used was a bottle of ink and a pen," she recalls, "because I read somewhere that that's what some famous illustrator used. I never colored anything in."

At about the age of ten, Mary first encountered the work of writer and illustrator Joan Walsh Anglund. The discovery would have a profound effect on the budding artist. "She was a *major* inspiration to me," Mary says of the artist who became well-known for her small, often inspirational gift books. "I mean, she just drove my life for a while. That was the very first time I had ever seen a little book like that, a picture book that was for children *and* adults. They were five by seven inches with one sentence and one little illustration on each page. I just loved them. I'd ask at the bookstore when they expected a new one in, and I'd be so excited while I waited for it. Then I'd buy it and try to imitate her." Anglund's spare illustration style seemed accessible to the young artist "They were pretty simple drawings," explains Mary, "and I thought, 'I could do this.'"

More than thirty years later, Engelbreit's gift books dominate the same industry that Anglund's work helped create, a fact that Mary still has trouble believing. "As a matter of fact, I was so thrilled when I went into our neighborhood bookstore not long ago and went to the gift book section—it's always filled with Joan Walsh Anglund's little books. Well, there were my books right next to hers! It's so wonderful! I felt like I had come full circle."

A Little Book About Books
Age 11

A passion for reading and the early influence of writer/illustrator Joan Walsh Anglund led Mary to write and produce her own book at age eleven. She titled the twenty-page volume *A Little Book about Books* and gave it to her mother as a birthday gift in 1963.

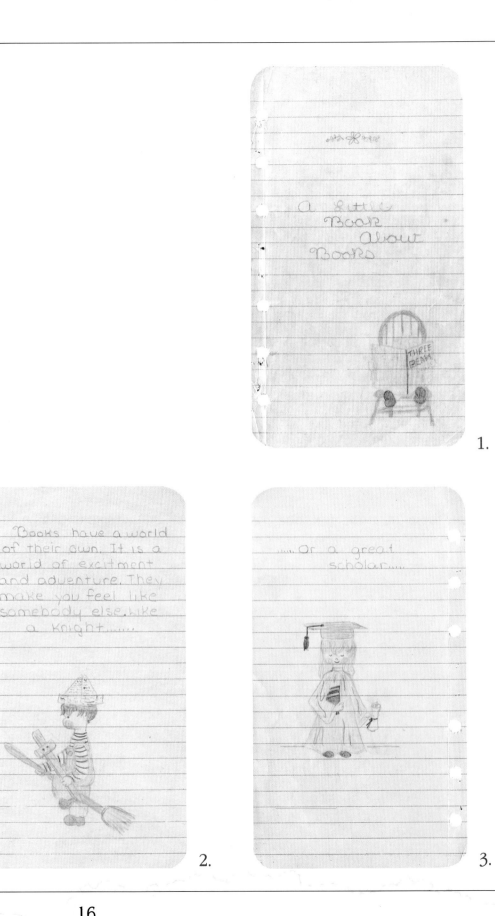

1.

2.

3.

4.

......Or even a farmer.

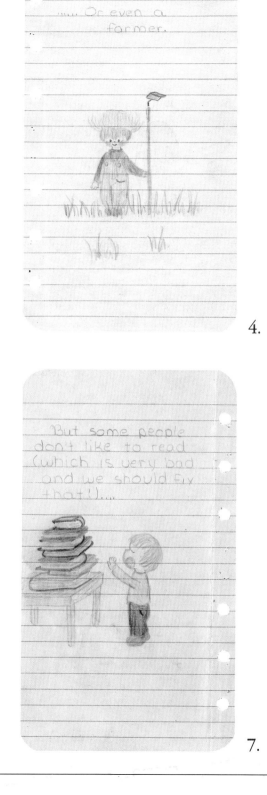

5.

A book can also bring you happiness....

6.

......Or sadness.

7.

But some people don't like to read (which is very bad and we should fix that!)....

8.

....And others havn't learned yet.

9.

...So that is the reason why we have teachers....

To teach the
ones who don't
know how to
read, and...........

10.

.......to teach the
ones who don't
like to read to
love to read.

11.

People with jobs
have to read
books to know
what to do.

12.

and then again
some people just
play with books
(which we really
shouldn't do!)

13.

Books can also
tell us about the
past.........

14.

.......the present.......

15.

18

......and the future.

16.

They can tell you about far-away lands...

17.

......Or Numbers......

18.

...And they can even teach you to spell!

CAT

19.

So you see, you will never outgrow your love for books, and............

20.

......everybody has at least one friend, and that is A Book.

21.

A Little Book About Books
High School, Age 17

Six years later, Mary reprised the book using the same words but updated illustrations and, once again, presented it to her mother on her birthday.

For Mommy on her Birthday

Love,
Mary

1.

2.

"Books have a world of their own. It is a world of excitement and adventure. They make you feel like somebody else. Like a knight....."

3.

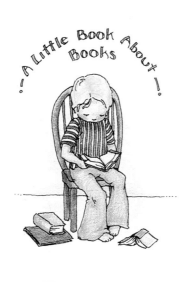

Or a great scholar......

4.

Or even a farmer.

5.

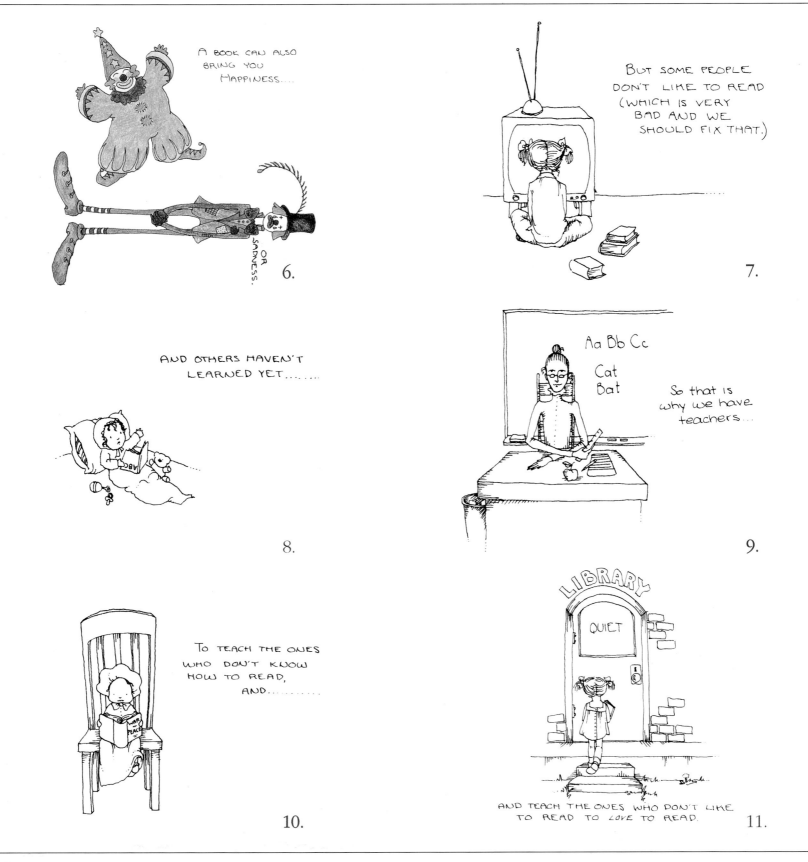

A BOOK CAN ALSO BRING YOU HAPPINESS....

OR SADNESS.

6.

BUT SOME PEOPLE DON'T LIKE TO READ (WHICH IS VERY BAD AND WE SHOULD FIX THAT.)

7.

AND OTHERS HAVEN'T LEARNED YET........

Aa Bb Cc

Cat Bat

So that is why we have teachers...

8.

9.

TO TEACH THE ONES WHO DON'T KNOW HOW TO READ, AND...........

LIBRARY

QUIET

AND TEACH THE ONES WHO DON'T LIKE TO READ TO LOVE TO READ.

10.

11.

21

PEOPLE WITH JOBS
HAVE TO READ BOOKS
TO KNOW WHAT
TO DO.

12.

AND THEN AGAIN SOME PEOPLE
JUST PLAY WITH BOOKS
(WHICH WE REALLY SHOULDN'T DO!)

13.

BOOKS CAN ALSO
TELL US ABOUT THE
PAST....

14.

THE PRESENT....

15.

AND THE FUTURE.

16.

THEY CAN TELL YOU
ABOUT FAR AWAY
LANDS...

17.

22

18.

AND THEY
CAN EVEN TEACH
YOU TO SPELL!

19.

So YOU SEE,
YOU WILL NEVER
OUTGROW YOUR
LOVE FOR BOOKS
AND...

20.

EVERYBODY HAS AT
LEAST ONE FRIEND,
AND THAT IS
A BOOK.

- THE END -

21.

NEGLECT NOT THE GIFT THAT IS IN THEE

Although Mary's family always encouraged her in her artistic endeavors, the Engelbreit household was not particularly artistic. "I don't know where she got her talent," her mother says. "I can't draw a straight line. And my mother used to say she'd draw chickens with three legs, so it didn't come from us." But Mary's mother knew enough to recognize that her daughter had special gifts—of determination as well as artistic ability. "Her father would say, 'Mary, can't you do anything but draw? Go do your homework! Go do something!' But we could both see that she had talent, and we thought that it was marvelous."

Her sister Alexa tended to take Mary's hobby in stride. "Alexa wasn't really interested," Mary remembers. "That's just what I did, and she went off and did her things." Mary's art was simply a fact of life in the Engelbreit household. Alexa remembers that once while she was playing, she heard her mother call repeatedly for Mary to come and set the table. Alexa went instead, telling her mother matter-of-factly, "I'll do it, Mom—Mary's drawing." They knew even then that when Mary was drawing, it was serious business.

Mary's first experience mixing business and art came at an early age. Her mother remembers, "Mary's father built the girls a playhouse in the yard. They loved it, but I guess after awhile it wasn't exciting enough as a house and Mary decided she wanted to make a store out of it. She painted combs and barrettes, rocks and driftwood, doll furniture, all kinds of stuff, and she opened her store." The twelve-year-old Mary proved to be a savvy shopkeeper. "She sold a lot of stuff to the neighborhood kids and kids from her school," her mother recalls. But when Mary decided to expand her inventory, problems ensued. The store was forced to close when Mary sold her mother's graduation dress. Mary had neglected to get the supplier's permission first.

Mary's mother laughs about the incident now and holds the store up as a prime example of her daughter's fierce determination. "She decided to have a store, and come hell or high water, she was going to have a store," Mary Lois says. "Mary was relentless. So, when she said she was going to be an artist, I didn't doubt her. I knew she was going to do something with her art. I didn't know what, but I knew she'd do something."

When she was 12 years old,
Mary converted her backyard playhouse
into a store and sold hand-painted barrettes
and doll furniture to her friends.
Twenty-five years later,
Mary and her husband opened the first
Mary Engelbreit retail store (pictured above)
in St. Louis' restored Union Station.
Although this store has since been closed,
Mary's retail operations have flourished
with several stores now in operation
across the country and more being planned.

Mary's schoolmates were also well aware of her artistic aspirations, and they didn't hesitate to press their talented classmate into service. All through high school, friends would ask, "Will you do a birthday card for my boyfriend?" Of course, this didn't pay much, but it did wonders for the confidence of a some-what shy girl—and provided her with lots of practice. Mary never minded obliging them—she was going to draw anyway; someone may as well put her efforts to good use.

The subjects of Mary's work in her junior high and high school days were probably typical of any adolescent girl growing up in the '60s. Even then, she was illustrating quotes, mostly favorite lyrics from the songs of Joni Mitchell and Crosby, Stills and Nash. She drew nature scenes of mountains, flowers, and cozy cottages tucked among the hills. There were rem-nants from her storybooks, too, like elves, fairies, and wizards. And there were *lots* of little girls. The children she drew were thin limbed, often doe-eyed, and curiously, frequently footless. Mary had a terrible time getting feet to look right, so often she simply ended the drawing at the ankles. The frequent appearance of hats on the little girls is evidence of a lifelong Engelbreit insecu-rity. "I've always hated my hair," Mary explains with a laugh, "so for a long time, I drew my girls with hats and no hair." Not surprisingly, many of the little girls she drew also wore glasses.

The fact that Mary loved drawing in high school is no surprise, but she also excelled in a less likely area: drama. Although she battled fierce stage fright before performances, Mary found great artistic satisfaction once on stage. "I loved it, and I think I was really good at it," she says. Good enough, in fact, that after graduation she was offered and accepted membership in a local theater group in St. Louis. "Acting and drawing were similar in that you get to create a whole situation—any situation you want," she explains. The difference, of course, is that you don't have to draw in front of an audience, and that difference would spell the end of Mary's thespian aspirations. "I was cast in a play, and I panicked," she explains. "I quit, and haven't done it since." It may be the only artistic project that Mary has started and failed to finish.

Mary's classmates' enthusiasm for her handmade cards was all the encourage-ment she needed to take her hobby (and her passion) to the next level. Inspiration struck during a visit to one of her favorite neighborhood shops. On the following page, Mary recalls the day she struck her first distribution deal.

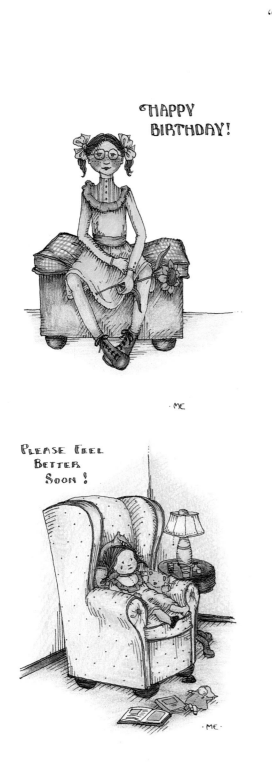

HAPPY BIRTHDAY!

· ME ·

PLEASE FEEL BETTER SOON!

· ME ·

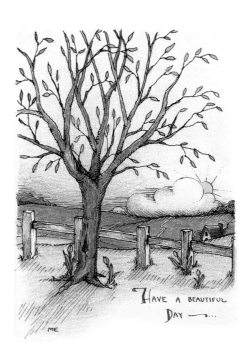

HAVE A BEAUTIFUL DAY —...

ME

"Foelich's was a very nice card and gift shop. They sold all kinds of greeting cards, little painted wooden figures from Germany and some really beautiful German toys. My friends and I would always end up there on Saturdays and spend what little money we had. So one day I went in with some cards like the ones I had made for my friends at school and asked the couple who ran the store if they would sell them. I remember the day. I was very nervous, but I was so happy when they said they'd put them in their shop. And they sold them all! I couldn't make them fast enough. She'd call and say, 'Well, I need about four dozen more,' and 'Could you do some birthday and some wedding . . .' She'd call with an order every week, but I didn't mind because they were really simple. They paid me a quarter for each card and sold them for fifty cents apiece. Eventually, they raised the price to one dollar and paid me a handsome fifty cents apiece!"

—*Mary Engelbreit*

· FOR YOU ·

ME

· HAPPY EASTER ·

Mary's desire and talent were never a question, but the practical matter of becoming an artist was a mystery to Mary.

Looking back now, Mary marvels at the popularity of those early cards. "People would wait for them and buy them as soon as I delivered them—and they were so ugly," she laughs, "truly horrible!" But despite Mary's harsh critique of her early work, she believed in it enough and was buoyed enough by her success to never question that she would someday make her living as an artist.

Mary was never shy about revealing her future profession to family members, teachers, or friends. But one declaration in particular stays with her mother. "One day I was cleaning the house, and I was showing Mary how to clean the bathroom and sweep down the stairs with a whisk broom," Mary Lois recalls. Mary, however, failed to see relevance in the lesson. Ann Estelle herself would have been proud of Mary's response to her mother's attempted domestic tutorial. "Mary said to me, 'Mother, I don't have to know how to do that. I'm going to be an artist and I'm going to have a maid.' She was willing to pull her share of the load," her mother explains, "but she didn't want to devote her life to learning how to clean the

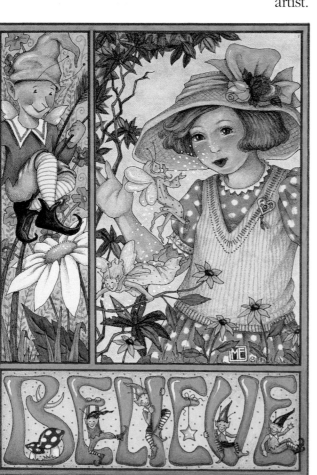

house." (Mary laughs about this now and muses, "Why I thought being an artist and having a maid were connected, I'll never know.")

Though Mary's desire and talent were never a question, the practical matter of becoming an artist, and specifically a book illustrator, was a mystery to Mary. Her parents' support was unconditional and unwavering, but beyond their encouragement, they had no real practical knowledge or experience to impart to their talented daughter.

"I thought it was marvelous that she loved drawing so much, and I knew she had talent, but I knew nothing about art," her mother explains. "I certainly couldn't guide her, although I would tell her if I didn't like something. I never said, 'Oh that's wonderful' if it wasn't. She had to educate herself about it. She just slowly built the knowledge she needed. Looking back now, I don't know that she knew exactly what she was doing, but she did the right things."

She didn't find much artistic guidance at school either. Little attention was paid to fine arts in either the elementary school or high school that Mary attended. In grade school, art class was conducted only once each week. High school was worse. She wasn't allowed to take art or drama because her grades weren't good enough.

DON'T LOOK BACK

Her love of drawing continued to grow, but what she learned was gleaned from her mother's antique picture books and her own experimentation, not from any teacher or mentor.

One incident in a fourth-grade art class remains with Mary to this day and reminds her of the frustration she often felt in school:

Once, in grade school,
we had the assignment of drawing
a bowl of fruit.
At the end of class one day
I put my picture away,
and the next time we had art,
it was gone. I wanted to start over,
but the teacher said, 'Oh no. You lost it.
That's your responsibility.
You're just going to have to sit here
while the rest of us draw this fruit.'
Well, I knew somebody took it.
It certainly wasn't my fault!
I remember I was absolutely
furious that they wouldn't let me
draw that stupid bowl of fruit over.
I thought, 'Who is this going to hurt?
What in the world is going on here?'
I was so irritated. I'm still irritated!
I had to sit there while
everyone else drew pictures.
It made no sense to me
and I think that's where
my lifelong distrust of schools began.
—Mary Engelbreit

Always among the brightest students throughout most of her tenure in grade school, Mary's interest began to wane in junior high. "I was a really good student in elementary school," she remembers, "but I hit seventh grade and just quit. I was not interested at all. I got terrible grades, and it kind of got worse as it went on."

Yet, even as she rejected school, her love of reading, like her love of drawing, remained unshakable. "When they'd give us a reading list for the summer, I would read every book on it," she says. "You know, you're supposed to pick out five books to read, but I'd go through the whole list. I really loved reading. But then I'd be so annoyed when I'd get back to school after the summer, and the teacher would ask, "In what chapter did such and such happen?" just to make sure you'd read the book. Nobody was really interested in *talking* about the book. It was so frustrating. My distrust of school deepened into intense dislike."

Her mother was aware of her daughter's discouragement. "I knew she was bright, and her teachers knew she was bright, but she didn't apply herself the way she could have. It just wasn't in her to do that. Her teachers would say, 'Mary never participates in class. That's a big part of her grade.' I'd tell her, 'Mary, just raise your hand. Answer some of the questions.' And she'd say, 'Mother, I know what they're talking about, why do I have to raise my hand?' How do you answer that? I told her it was part of her grade . . . but she couldn't wait to get out of school, to do what she wanted to do."

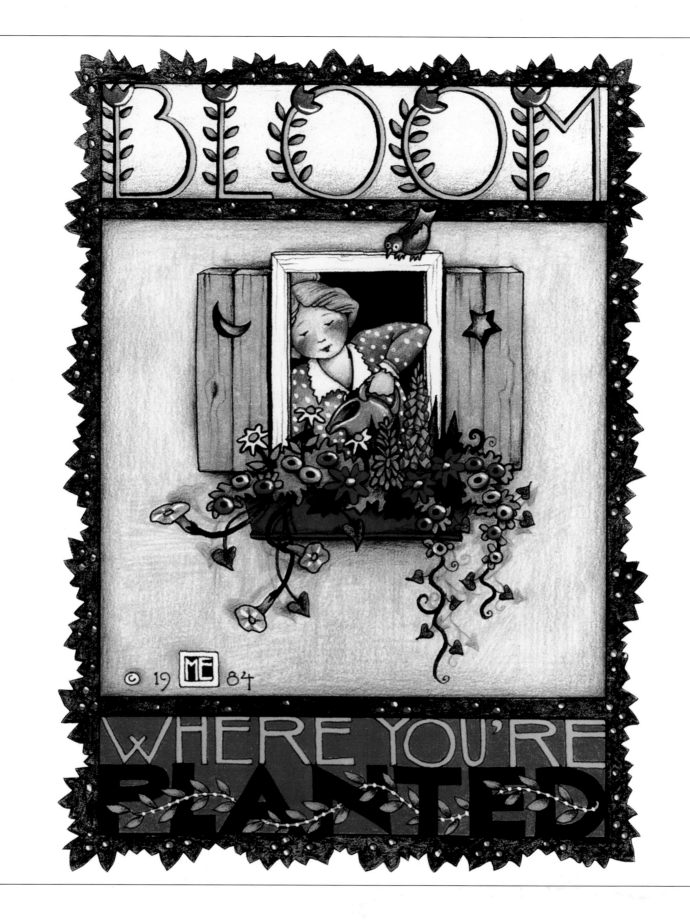

When you reach the end
of your rope,
tie a knot in it and hang on.
—*Thomas Jefferson*

Bloom Where You're Planted

Mary Engelbreit graduated from high school with the singular goal of becoming a children's book illustrator. The problem was she didn't have the slightest idea how to pursue this goal. The year was 1970, and enlightened thinking about gender roles hadn't yet trickled down to the administration at Mary's all-girls Catholic high school.

"The guidance counselor at the school was this shy little nun," she remembers. "She told everyone in my class—all fifty-two girls—to go to the local Catholic university and get a teaching degree in English." Mary protested: "You know, I'm thinking about going to art school. . . ." The response, she recalls, was less than supportive. "Oh, my God, no, you can't do that," the guidance counselor said. "I may as well have told her I was thinking about becoming a stripper."

Once again, Mary was left to her own resources. "I'd read a little bit about art schools, and the literature always said, Send your portfolio. But I had no idea what a portfolio was, much less how to create one," she explains. "My parents were always supportive, but they didn't know about art schools either. I don't know if they even knew there was such a thing."

But regardless of the information void, even if Mary had had more guidance, she admits that it probably wouldn't have changed things. "I had already made up my mind that I wasn't going to college anyway," she says. "I just wanted to get out of school. I wanted to start to work."

Choosing work over college wasn't an easy decision, but it's one that Mary stands behind today.

Starting to work is just what she did. As most of Mary's friends set off for college, she set off on a course for further self-education. She took a full-time job at Art Mart, an artist's supply store not far from her home. Choosing work over college wasn't an easy decision, but it's one that Mary stands behind today. "At the time, it felt pretty strange," she remembers. "I kept wondering, 'Am I making a really bad mistake here?' but I absolutely did not want to go on with school."

At Art Mart, Mary finally found the type of education she was thirsting for. The job was a revelation to the eighteen-year-old artist. Mary's eyes were opened, fully for the first time, to a world of job possibilities—and none of them required an English degree from the local Catholic university. Even now she recalls this period with fondness and a sense of discovery:

"First of all, a lot of really interesting people worked there—mostly young people who were seriously interested in art. And all of these working artists would come in to buy their supplies. Also, the man who owned the store had a gallery there, and he knew several fairly prominent St. Louis artists, and they would come in and talk to him and to us. So I got to meet people who were making a living making art, and it was very inspiring and exciting. I had no idea there were so many different kinds of jobs that involved art!"

Still, naysayers were never hard to find. Some friends, including an otherwise perfect boyfriend, doubted that she could achieve a career in art. "He would constantly ask, 'When are you going back to school?' 'What are you *really* going to do?' even the dreaded, 'Maybe you could teach.' Lots of people said that," Mary says. "There were a lot of people who just didn't think being an artist was a realistic goal. I think it seemed a little too vague and farfetched for regular, everyday life."

Mary's resolve, of course, was unshakable. "Looking back on it, I suppose it seems pretty thickheaded not to have paid *any* attention to anyone's well-meant concerns and very legitimate questions as to how I was going to do this. But I think part of the reason I was so confident was that my parents always said, 'Of course you can do that. Don't worry about it. Keep working for it, and it will happen.' I guess I believed what I wanted to believe."

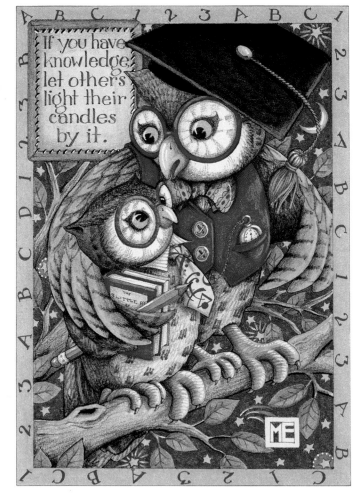

If you have knowledge, let others light their candles by it.

LIVES...GET ONE

"I decided to make it a policy to hang around with supportive people," Mary says of her strategy. "You need to do that, especially if you're going to try to do something that is out of the ordinary or a little bit harder or more complicated. It's difficult to operate with everybody telling you, 'you can't.'" Needless to say, the doubting boyfriend was eventually history. "But when I met Phil," she says, "he thought all of this was great. He said, 'There must be a way to do this, and we are going to find out what it is.'"

When she wasn't working at Art Mart, Mary would further immerse herself in the art world by attending student shows at the Washington University School of Art. Had she had the grades, the money, and the guidance, this is likely where Mary would have gone to school. Seeing the work of her peers on display held mixed emotions for Mary. "I'd look at the student paintings and wonder if I could ever learn to do that," she says. But the yearning to join never got too strong. For one thing, she noticed a lack of individualism in the work. "At the student shows, a lot of the art looked alike to me, all the same every year, all interchangeable. Maybe I was jealous," she muses, "but I wasn't that interested in painting anyway. I really wanted to draw."

While Mary didn't find the art in the university shows particularly inspiring, she was inspired by the *idea* of the shows. With typical moxie, Mary decided that if the art school could put on a show, so could she. She knew that a few of her coworkers at Art Mart would jump at the chance to exhibit and maybe even sell their work. "It was like in an old Andy Hardy movie," Mary remembers with a laugh, "I said, 'Hey, let's put on a show!'" The show was a hit, and all of Mary's drawings sold. Prices ranged from fifteen to twenty dollars.

Mary spent two years working at Art Mart, attending student and professional shows, practicing her own techniques, and in general, continuing her education into the art side of the art business. She loved working in the artistic community, but she wanted more. Her goal was to support herself as an artist, not by selling artists' supplies. She knew that it was time to take the next step. That step was a job with a one-man advertising firm in St. Louis.

Woman in Hat with Crow and Cat,
1974, pencil
In the early 1970s,
Mary experimented with a range of
artistic styles and subjects,
but still drew primarily in black line
with an ink pen or pencils.
The drawing below is a self-assigned
character study done while
Mary worked for a small St. Louis
advertising agency.

"I got a job illustrating all kinds of advertisements at this tiny ad agency called Hot Buttered Graphics," she says. "It was great because the owner taught me everything about the *business* of art. You know, how much to charge, how to bill, and how to work fast so you can make enough money. He taught me a lot of things. And it was just the two of us, so I worked on all kinds of different projects. I did the illustration. He was more of the designer. I think I learned more there in eighteen months than I would have in four years at an art school."

At the time she began illustrating ads, Mary did most of her work in the pen-and-ink style that she had polished over the previous decade, but shortly after taking the job, she made a discovery that would change her work forever: color, or more specifically, colored markers. Mary remembers her discovery of markers as an epiphany of sorts. "For a long time I did only black-and-white draw-

ings because I was terrified that I would ruin them if I used color," she explains. "Then I started to use colored pencils so I could erase, but they would never erase all the way, and the colors were so pale and washed-out looking that I preferred black and white. But the man who owned the ad agency had this huge set of permanent markers, and he taught me how to use them so that nothing would run and everything would look good." Like Dorothy opening the door on the Technicolor splendor of Oz for the first time, Mary was exhilarated at the possibilities. "I was so excited," she says. "It felt great to be able to go in a new direction with my drawings."

It was during this period that Mary's signature style, technically speaking at least, was forged: pen-and-ink outlines, followed by flat color supplied by permanent markers, and then colored pencils for shading and highlighting. It's a simple formula that took years to hit upon and is now copied by illustrators everywhere.

The ad agency job didn't last long. After about a year and a half the owner left town, and left Mary without a steady job. But she wasn't without work. The contacts she'd made brought her a fairly steady flow of freelance illustration work, and without really planning it, Mary was suddenly in business for her-

self. By this time she had moved out of her parents' house and into an apartment with her sister Alexa. With a studio in the dining room and enough freelance work to pay her share of the $190 monthly rent, Mary had become, at age twenty-one, a self-supporting, self-employed, independent artist. "I wasn't making a lot of money, but it was enough," she says looking back on her first taste of adult independence. "I loved it."

Mary had no grand plan for her career, but it seemed headed in the right direction. Since graduating from high school she had sold art supplies and then actually worked as an artist illustrating ads for a small agency; finally, she had made the transition to self-employment, working on a full-time freelance basis. Still, she wasn't exactly where she wanted to be. For one thing, as a freelance illustrator she was producing illustrations based on the direction of other people. She always felt that she did better (and certainly more satisfying) work when it came from her own head.

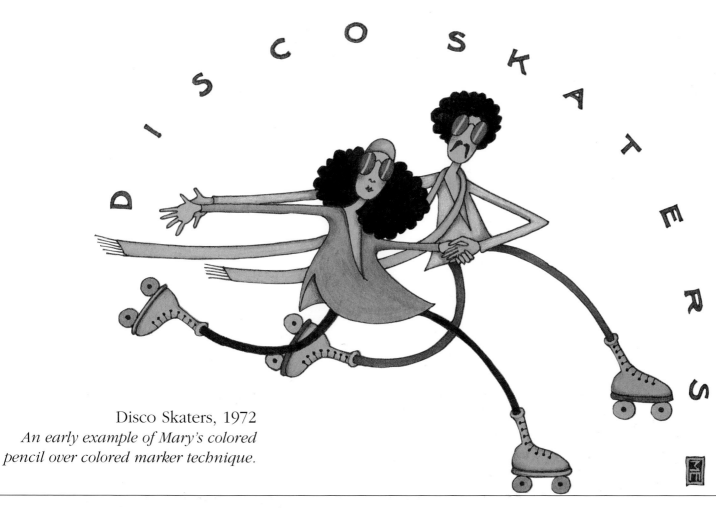

Disco Skaters, 1972
An early example of Mary's colored pencil over colored marker technique.

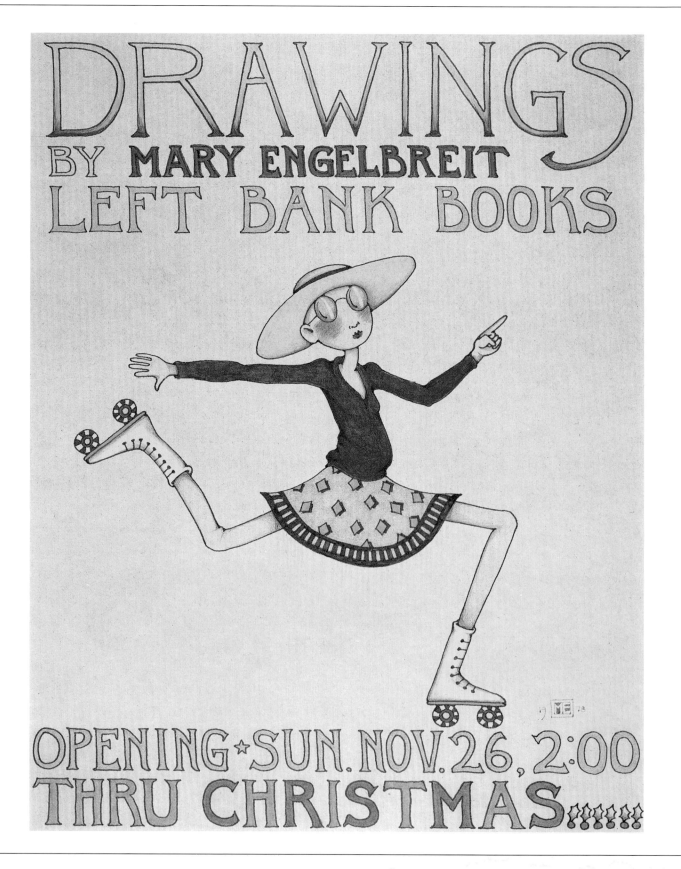

This feeling was always validated when she exhibited her works. Mary participated in gallery showings whenever she had the opportunity. The venues were usually informal. In 1979, Mary began an annual tradition of holding a holiday show in the modest basement gallery of Left Bank Books, an independent bookstore near her home. A review of this first show in the *St. Louis Post-Dispatch* encouraged readers to "rush on over to the store for a peek at Mary Engelbreit's drawings."

Early successes like these left Mary exhilarated but also a little scared. She had spent her life edging toward a dream, a dream she'd had for as long as she could remember. Now it seemed within reach, and it was leap-of-faith time.

Even then, Mary knew that this was a time of transition. "I can't explain it," she says. "I was just so hopeful that I could make it as an artist. And I felt like it was going to happen, but I had no idea how." At twenty-two, what Mary really wanted was what she had wanted since she was eleven years old and drawing in the linen closet of her parents' house. She wanted to illustrate children's books. But like so many times before, she found that she was left to her own means in pursuing her goal.

"These enchanting illustrations that magically balance humor and wit with delicacy, innocence, and wonder . . . not only would charm an adult into buying a book but charm the child as well. . . . Hearts, sartorial snakes, little frogs, mice, kittens and all sorts of small, odd but perfectly sensible things crowd into the pictures. . . ."

—*St. Louis Post-Dispatch,* 1979

In retrospect, Mary realizes that her path clearly wasn't the easiest or most efficient one. She knows that she made lots of mistakes in those early years—some that still leave her shaking her head today. She's quick in offering an example. "The first time I sent my portfolio to a greeting card company, I sent *originals* of my work and didn't even keep copies!" she says incredulously. "I never saw them again!"

But regardless of the occasional miscue, she realizes the value of having developed her talents on her own, outside of the academic system. For all the practical knowledge she missed, she knows that what she found, or more accurately, what she *retained* is even more valuable; she retained her visual voice and her unique style.

Mary was free to develop her style without the input of professors or peers. The only rules imposed were her own. Simply put, she did what she liked. "Nobody was telling me that this was or wasn't the way to do it," she explains. "So I just did it the way I wanted to, and it happened to be different than anything else that was out there. Whereas, if I had been in school, I think I prob-

ably would have been toeing the party line. Honestly, I don't think that I would be doing this right now, I think I'd be working in an ad agency or an art gallery somewhere."

Freelance advertising work continued to pay most of Mary's bills in the early '70s, but any enthusiasm she'd had for advertising work was beginning to fade by the middle of the decade. "I never took art direction very well," she explains with a wry smile. "It's no fun drawing something that you don't care about. Once I illustrated a shoe box for a big shoe company. It had a picture of a girl on the top. I'd get it back with comments like, 'Can you make her foot point more to the right?' 'Can you make her look to the left instead of the right?' Everyone needed to get their two cents in . . . it drove me crazy! I'm afraid I'm just not much good at being directed. Also, I believe, and I've talked to other artists who think this, too, that some art directors make some pretty silly changes simply to make changes."

Fortunately, for every measure of frustration and rejection in her advertising freelance business, there was acceptance and enthusiasm for the work she exhibited (and nearly always sold) at art shows.

Mary's husband, Phil, remembers the first time he attended one of Mary's

shows. They had just started seeing each other, and Mary asked him if he'd like to come along and help her set up the show. "It was outdoors, in fact, the drawings were hung on a tennis court," he says. "There were several artists in the show, and I remember watching people look at Mary's work. They would look at it and laugh or smile and then immediately go find the people they were with and drag them over to Mary's work, saying, 'You've got to come see this!' I knew right then that she was going to be successful, because she made a connection with people."

Mary had made a connection with Phil, too. He claims he knew there was something special about Mary the first time he saw her apartment. "I remember the first day I walked into her apartment thinking, 'This is so comfortable.'" He says, "I was used to people who had very little interest in where they lived. She had wonderful taste, and her place was so cozy. She had framed prints and artwork all over the place. She had such a good eye and a good artistic sense. I remember asking her who had done a couple of the pieces, and she said, 'Those are mine.' I was amazed."

Phil was also extremely impressed by the young artist's self-assuredness. At an age when most people are stumbling around in a postcollege haze and trying to find themselves, Mary's single-minded life goal was refreshing. "She's always had this clear vision of who she is and what she wants to do," he marvels. "Very few of us have that."

Mary and Phil began dating in 1974. Phil was well-established as an administrator in the St. Louis county juvenile court system, and Mary continued with her freelance illustration work, tackling everything from magazine and newspaper editorial illustration to posters and print ads. She even illustrated a series of law books for junior high school–age kids.

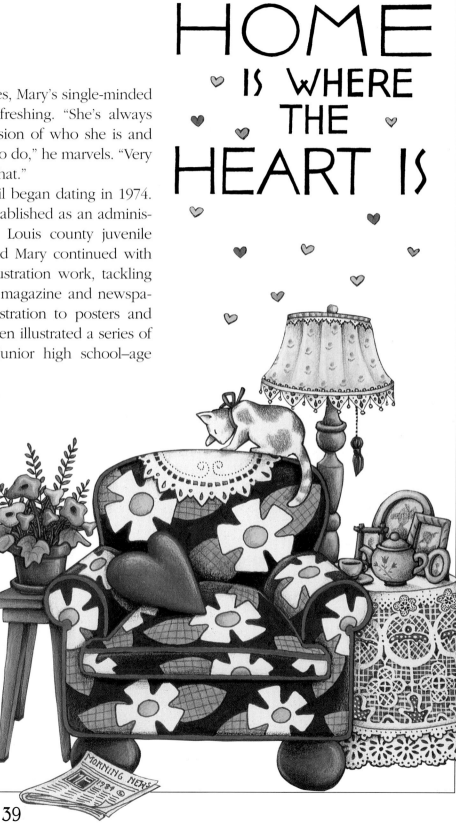

HOME IS WHERE THE HEART IS

39

For a short time, in 1976, Mary's work could actually be seen regularly in the *St. Louis Post-Dispatch*. She worked as a staff editorial artist for three months. When she learned that male peers with the same amount of experience were being paid more than she was, she objected and was fired. "I've never seen anyone so happy to lose a job," jokes her husband. "She was ecstatic because now she didn't have to get up and go to work at 8:30, because she worked on her drawings until 2:00 in the morning. In fact, she still does."

Mary and Phil were married in 1977. The budget was tight. "She was working as a freelance artist, getting a little work here, a little work there, living from hand to mouth," explains Phil. "We lived on a social worker's salary so that she could continue to draw." But even when finances were tightest, Phil never doubted his wife's career choice and never pressured her to get a "real" job. "From the beginning," he says, "I

Editorial illustration for St. Louis Post-Dispatch*, 1976.*

saw in Mary a couple of things. Number one, I saw great potential. I knew that she had tremendous talent and that she could make a living at this if she got the right breaks. But I also saw that this was the only thing she ever wanted to do, and if I was going to be with her, this was part of what I was taking on. She wasn't going to go out and get a straight job. She wasn't going to put on a nice suit every day and go do whatever it is you do wearing a suit. She was going to draw."

Shortly after they were married, Mary decided that if she was ever going to get anywhere as a book illustrator, she was going to have to leave St. Louis, at least temporarily. Phil had a friend in publishing in New York City who helped her set up some interviews, and Mary set off with portfolio in hand to show her work to art directors.

The wide-eyed-innocent-follows-her-dream-to-the-big-city-and-makes-it-big cliché is almost too obvious, but it applies. Except for the making-it-big part—that comes later.

Mary laughs when she thinks back on that first trip to New York. "It was kind of fun and kind of scary and, ultimately, kind of pointless," she says. "I had never done anything like that alone before; I felt like I was dressed all wrong, and I said all the wrong things—

"I guess I was just disappointed that no one said, 'Oh, yes, here, illustrate all our books— we thought you'd never ask.'"

I knew that I was out of my element there. I realized with the first person I saw that this was *not* how to get a job doing this. But our friend had been nice enough to set up all of these appointments, so I went to publisher after publisher, and I have to say that everyone was very nice. They all took the time to look through my portfolio, and almost all of them said that they liked it but very rarely, if ever, bought work this way. It was definitely a major eye-opener, which I needed."

What already seemed like a pointless trip turned even more discouraging when the last art director that Mary talked to suggested a different direction for her work. "She said that I should consider illustrating greeting cards," remembers Mary. "I was kind of crushed. At the time, I really had my heart set on illustrating children's books, and to me greeting cards were a real come-down. I just didn't know much about that business. I didn't understand how you could make money with greeting cards. I had never heard of a royalty. I thought greeting cards meant working at Hallmark, and I knew they only hired people with college degrees. I also thought greeting cards meant hearts and flowers and fuzzy teddy bears with big scary eyes and sappy verses. I don't know why I thought that, since neither I nor anyone

I knew ever bought cards like that, but I guess I was just disappointed that no one said, 'Oh, yes, here, illustrate all our books—we thought you'd never ask.'"

Of course, what neither the art director nor Mary knew was that this parting bit of advice would change the course of Mary's career forever.

After four days in New York, Mary returned to St. Louis somewhat deflated and wondering what to do next. But her disappointment didn't last very long. The art director's comment stayed with Mary, and she decided to turn her attention to greeting cards. She looks back on this decision now with the attitude of an unabashed optimist. "At the risk of sounding like a Polly-anna, I can hardly think of a disappointment that you can't turn around into a good situation," she says. "It sets you off on a different track, and there's nothing wrong with that. It just

makes you look at things differently." Looking at things differently, after all, had always been an Engelbreit strong suit.

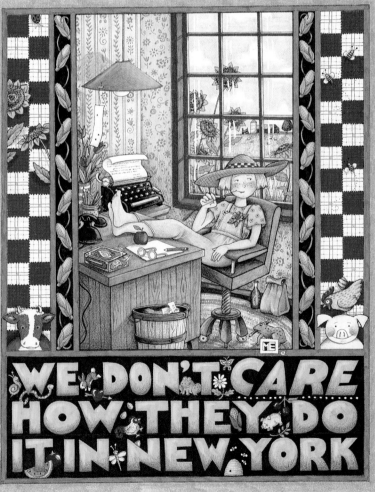

WE DON'T CARE HOW THEY DO IT IN NEW YORK

One of the ways she started to look at things differently concerned the composition of her drawings. "At the time," says Mary, "I would draw one person in a drawing holding flowers or something. One of the art directors I met in New York said, 'Put more people in your drawings and have them doing something, you know, moving.'" It's the kind of advice that seems simplistic now, but probably just the kind of feedback Mary missed by not going to art school.

"I came right home and practiced drawing lots of people in my illustrations," she remembers. "I had never done that before because I wasn't sure I could pull it off. It was hard to get everybody in the picture the right size."

Although Mary followed the advice she picked up on her New York trip, she also stayed true to her own innate sense of what to put into her work. Essentially, she drew what she knew: poignant moments from childhood, depictions of familial love, little girls sharing giggles. She didn't realize that she was supposed to think about what the market would respond to, or even who the market was. As she had done since childhood, she drew what she liked without much concern about whether other people would like it too.

Of course, other people *did* like it. All she had to do was get her drawings in front of them—and that turned out to be a fairly simple matter. Mary remembers, "The art director who had suggested greeting cards told me, 'Go around and look at all the cards in the stores. Look at the backs of the ones you like the best and see who makes them— that's who you should send your drawings to.' So I did that. I sent my drawings to two companies, and I heard from them both." One of the companies paid $150 for three illustrations. ("I was thrilled to get it," remembers Mary.) Another signed her to a short-term contract.

The cards sold well, and Mary's enthusiasm for the greeting card business grew quickly. In fact, she was amazed to find that the type of drawing she'd been doing since childhood was more suited to greeting cards than to books. "I don't know why it had never occurred to me to draw for greeting cards," says Mary. "But once I realized that I could do these bizarre little one-shot illustrations that I'd always done, I really liked it. The only difference was that I had to think about occasions, but that made it even more fun. Now I've done both, and I actually like doing cards much better than books."

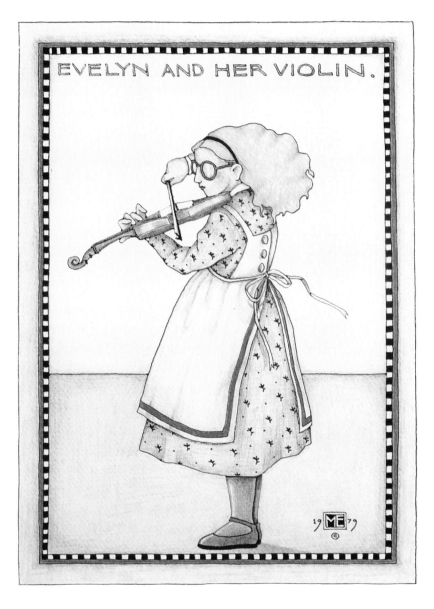

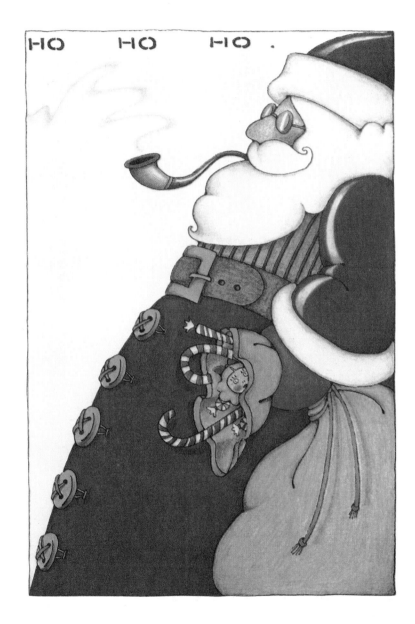

Evelyn and Her Violin, 1979
*These two drawings were among the first
that Mary sold to a greeting card company.*

Ho Ho Ho, 1979

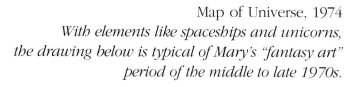

Map of Universe, 1974
With elements like spaceships and unicorns,
the drawing below is typical of Mary's "fantasy art"
period of the middle to late 1970s.

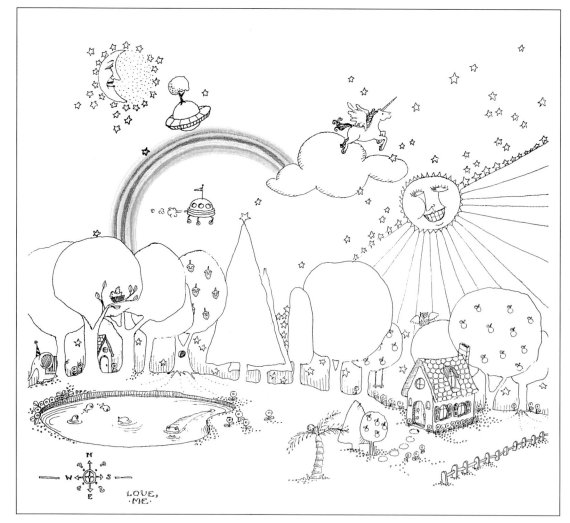

With the birth of her first son, Evan, in 1980, the content of Mary's work underwent a fairly dramatic change. For several years preceding this event, Mary had been drawing predominantly what she calls "fantasy art": princesses, gypsies, clowns and jugglers, dragons and other winged creatures, many of which would today go unrecognized as ME creations even by her most loyal fans.

"I went through a few different phases," Mary explains. "As a child, I copied my mother's old storybooks, then I created my own illustrations for books that I read. In high school, I liked Peter Max, Seymor Chwast, and Milton Glaser—and drew a lot of things in the '60s rock poster style. Then after high school I started doing a lot of this fantasy art stuff. Some of it is pretty strange, and I don't really know what the inspiration for it was, but I always loved fairy tales so it was probably an extension of that. It was as if I was illustrating books that weren't there." She laughs at her own explanation and continues, "I always wanted things to look like book illustrations, so I guess these were illustrations for imaginary books."

But with the birth of Evan, fantasy gave way to reality. She no longer had to rely on imaginary stories for inspiration. Inspiration surrounded her.

"After I became a mother, the things

happening in my day-to-day life were more interesting to me than unicorns and castles," she says. "And since we lived the same kind of life everyone else seemed to be living, I figured these things must be interesting to other people, too." Having a child, of course, put Mary more in touch with her maternal instincts, but besides that, becoming a mother sharpened a sense of nostalgia for her *own* childhood. Mary has always had an excellent memory, and as a new mother she found that she was drawing upon it more and more.

By age twenty-eight, Mary's detail-rich and deeply colorful illustration style had found a permanent match in her nostalgic, whimsical, but always real subject matter. It was like Gilbert finding Sullivan. The result was harmonious and right. She hasn't looked back since.

"I have always appreciated the little things that happen every day: watching my kids play in the backyard . . . laughing with friends . . . a hug . . . a beautiful sunset. From the time I was little, I collected those little moments in my head. That's what I illustrate now instead of books— those little moments."

Can You Come Out and Play, 1982
By the early 1980s, Mary had turned her attention toward more realistic subjects and depictions of everyday life. Mary's first son was one year old when she drew the baby pictured above in 1981 (titled, Manners).

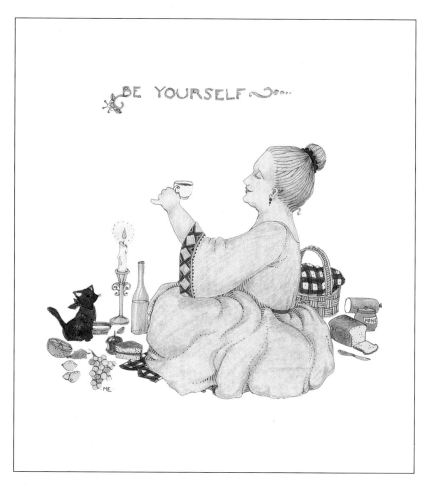

Be Yourself, 1970

*By the early 1980s, Mary's easily recognizable
artistic style had fully evolved.
Often, Mary revisits a favorite theme,
updating and tweaking it, but always sustaining
the whimsical and heartfelt sentiment
that has become her signature.
On this and the following page are popular
Engelbreit drawings and their earlier incarnations.*

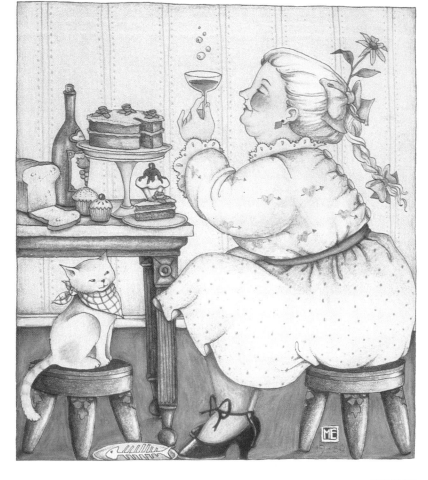

Be Yourself, 1980

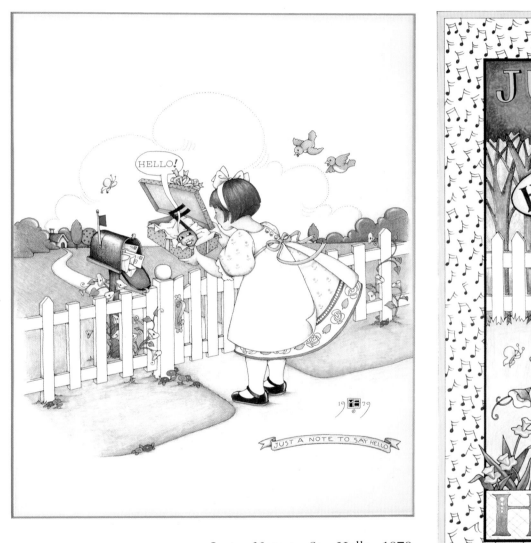

Just a Note to Say Hello, 1979

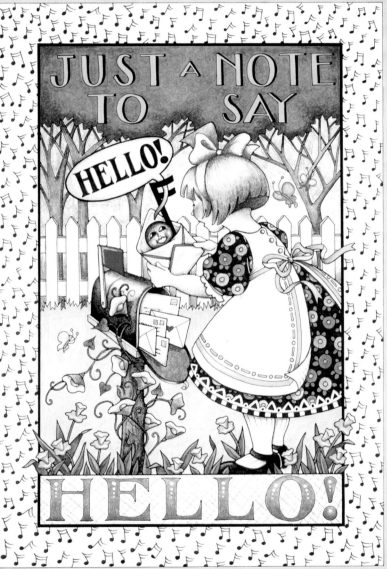

Just a Note to Say Hello, 1983

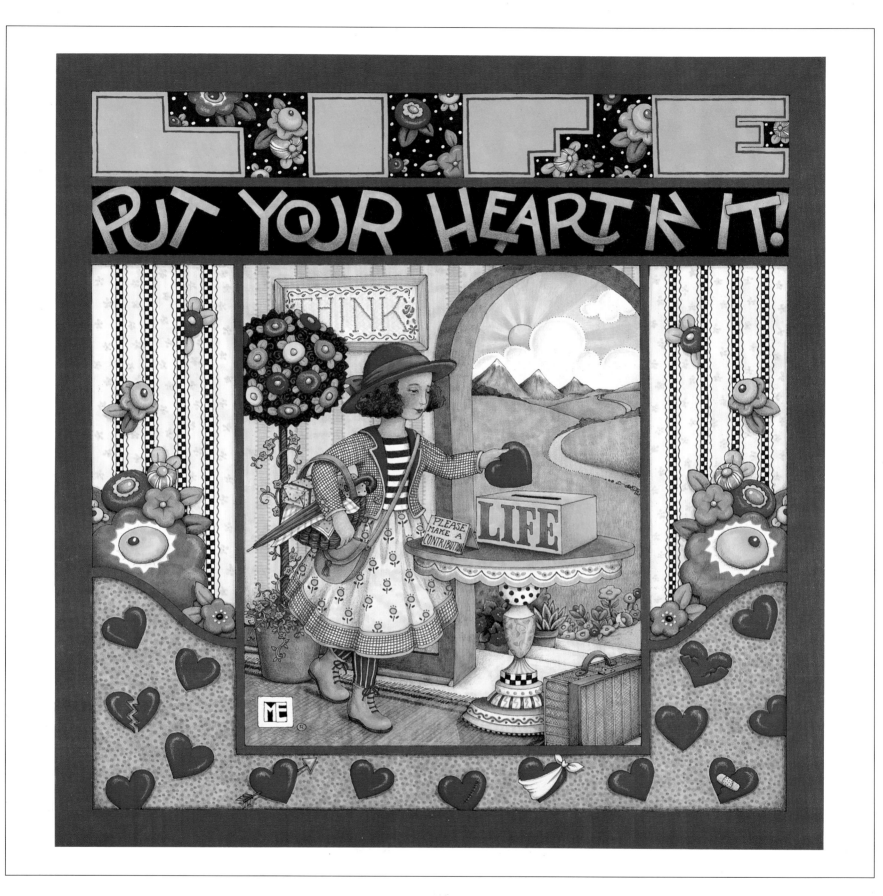

She loves what she does.
She's so full of ideas;
she wants to put them all down on paper.
—*Mary Lois Engelbreit*

Put Your Heart In It

Once comfortable with the greeting-card format, it didn't take long for Mary to grow impatient with the companies producing her cards. "They weren't asking me for a lot of cards, and they were rejecting some that I was sending that I really liked. The first company rejected 'Life Is Just a Chair of Bowlies'!" she recalls. "I would call to suggest, 'Why don't you make posters out of a couple of these, or how about a calendar?' But they weren't interested. I wanted to get this show on the road, going in the direction I wanted," she says. "So I decided I would do it myself."

Such enthusiasm is typical of Mary, according to Greg Hoffmann, Mary's friend, attorney, and chief executive officer of The Mary Engelbreit Company. "I always believed that I was the most impatient person in the world," he says, "until I met Mary. She knows where she wants to be, and she gets going. It's everybody else's job to catch up to her."

When Mary decided to produce and sell her own line of greeting cards, she had a three-year-old son and was eight months pregnant with her second child. Proper timing, she insists, is overrated.

"There's always a reason not to do things. It's too expensive, or it's not the best time, or this, or that, but I believe there are wonderful opportunities constantly sailing by, and you have to be ready to grab them. Even if you can't really see to the end of it, you have to be willing to jump in. I don't think a lot of people are willing to do that, but I like it. It's scary," she says, "but very fun."

THANKS. I NEEDED THAT.

Mary brought to her venture no college education, very little business experience, and even less start-up capital. What she did have was a burgeoning talent and a boundless desire to illustrate. She knew that these qualities alone, however, wouldn't pay for her printing costs.

To realize the vision of having her own greeting card company, Mary needed a partner. When a St. Louis entrepreneur offered to buy in, she was thrilled. The only problem was that the investor bought in at 55 percent. In her enthusiasm to get things rolling, Mary had given up what she wanted in the first place—control of her own company. In retrospect, she realizes that it wasn't the most savvy business deal. "I was so happy and grateful that this guy was going to put up money, I forgot that I was also bringing something fairly important to the table," she says, shaking her head. It was another tough lesson in the school of real-life business.

Despite frequent disputes brought on by the imbalance of power, production of her first batch of cards went smoothly. By the spring of 1983, Mary was ready to take her product to market. Once again, it was back to New York City, this time to the National Stationery Show, an annual convention where essentially every company in the gift and greeting card industry displays and tries to sell its products to retailers.

"We printed twelve cards in full color—which is *nothing!*" recalls Mary. "We actually went to the stationery show with our twelve pathetic little cards. Nobody ever does that. Everybody there has four hundred cards." Mary, it should be noted, is sometimes prone to exaggeration, but her offering of twelve cards was indeed meager by National Stationery Show standards.

On the back of each of the twelve cards was printed a single sentence; a sentence that appears on the backs of all her cards, even to this day:

This illustration is by Mary Engelbreit, who thanks you from the bottom of her heart for buying this card.

The sentence was no marketing ploy. Mary meant every word. "When I started that company, we had borrowed a lot of money, and we were broke," she explains. "I really felt like that—I was so grateful if anybody would buy a card. I decided to put the message on the back of the every card so people would know how much I appreciated their business."

The National Stationery Show was Mary's true baptism into the greeting

REAL LIFE

card business, and she loved it. "I just couldn't get over it," she says. "I was floored. It was so big! I had no idea there were so many alternative card companies. And it was very exciting because in that huge place our twelve little cards were getting a lot of attention. They sold! Part of the reason they sold was because I had been out in the marketplace already, albeit in a small way, with those two other card companies, so people were already familiar with the cards and knew that they sold well. At that show we were also approached by a publishing company to do a calendar, and we made a deal with a licensing agent. It really took off, and I was ready to go!"

Stylistically, Mary's cards were different from anything else on the market. Her illustrations often depicted simple scenes but were rendered in intricate detail with deep colors and the mixture of sincerity and playfulness that would become an Engelbreit trademark.

Mary's tendency to incorporate amusing or profound quotes into her drawings was another distinguishing feature. The technique was new to the greeting card world, but familiar to Mary. Her childhood dream, remember, was to illustrate children's books, and in the books she loved, a key line was often pulled out of the text and illustrated. Her

greeting card designs merely reflected what she had been practicing since she was a young girl.

Mary's love of reading had helped her build a vast collection of favorite quotes, and, along with "real life" quotes from friends or family members, these sayings often found their way into her illustrations. One of Mary's most popular illustrations, "Life Is Just a Chair of Bowlies," is just such a "found" quote. Mary heard an old boyfriend's father sputter the spoonerism and decided to co-opt his slip of the tongue for a card. Like her eyes, it seems, Mary's ears are always taking in potential card ideas and storing them for later use. Mary first drew "Chair of Bowlies" in 1976. In fact, it was among the twelve "pathetic" little cards she took to that first show in New York.

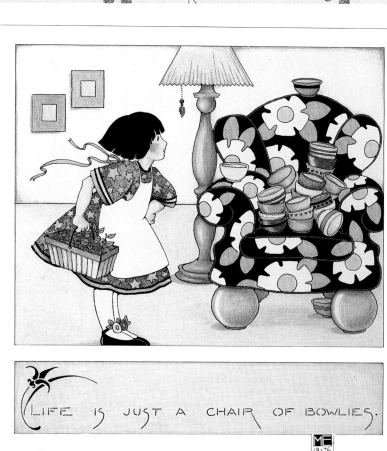

Life Is Just a Chair of Bowlies, 1976
Perhaps Mary's most famous and well-loved illustration,
"Life Is Just a Chair of Bowlies"
was first drawn by the artist in 1976.
Although the original drawing was rejected
by the greeting card company that published
Mary's cards, Mary included it among her first batch
of self-published cards.

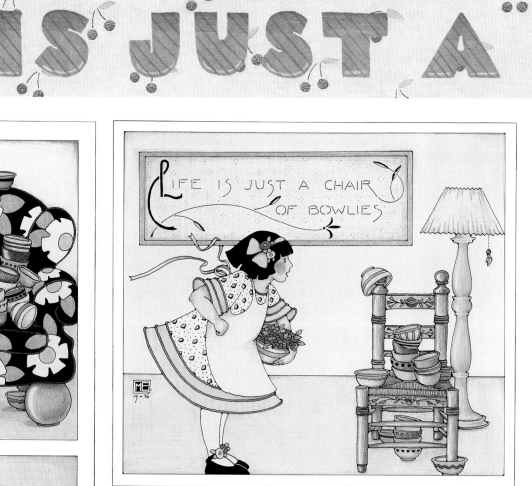

Life Is Just a Chair of Bowlies, 1979
Despite rejection by the greeting card publisher,
"Chair of Bowlies" was a big hit with Mary's friends.
She drew this revised version as a birthday gift
for one of them.

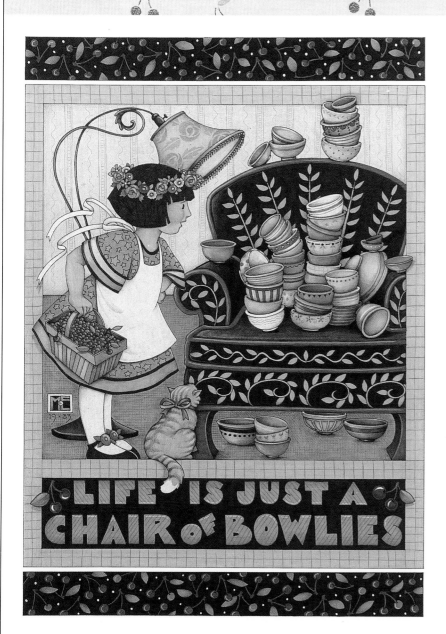

Life Is Just a Chair of Bowlies, 1983
*When Mary founded her own greeting card company
in 1983, this redrawn version of "Chair of Bowlies" led the way.
It has been among Mary's best selling cards
since its introduction.*

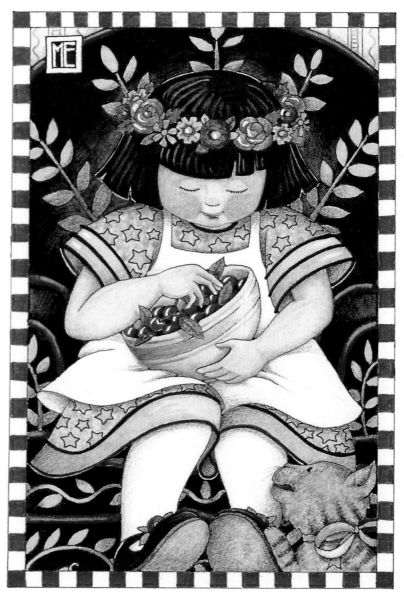

Little Girl Eating Cherries, 1990
*In the most recent variation on the theme, the
"cherry girl" finally gets a seat.
Mary drew this for the 1991 "Greatest Hits" calendar.*

For the next two years, Mary continued to create new cards and watched her tiny greeting card company grow exponentially. A small room in her basement served as the first office and warehouse. It took only six months for the company to outgrow the space. Mary leased a small storefront office, but in another six months needed more space again and moved around the corner.

Shortly after that, the company's rapid growth forced them to rent an entire building.

After two years in business, The Mary Engelbreit Greeting Card Company was producing nearly one hundred different cards and was selling a million cards per year. "We were a hot little number for a tiny card company," remembers Mary. But sheer numbers

don't tell the whole story of Mary's phenomenal success. The people who bought her cards found something in them that they didn't see in other places. As her husband had observed so many years ago, she was "connecting" with people.

"A lot of people I meet at signings say 'I feel like I know you,'" Mary says. "People seem to have such a personal connection to the cards. According to what people say in letters we get, they buy our cards when they *really* want to say something, and a lot of people tell me if they like a design they buy one to send and one to keep for themselves because it means something special to them and the person they're sending it to. That's really gratifying to me because it becomes a much more intimate thing. I feel like I'm personally communicating with these people."

Mary attributes her ability to connect with people to the "everyday" nature of the scenes she depicts: A mother straightens a child's painting while the child and the family dog look on; a father gently lifts a sleeping child into the top of a bunk bed; children catch fireflies in a jar on a summer evening. Most people relate to things like this. "My work has always been very personal," Mary says. "Most of my drawings are based on events that have happened in my own life."

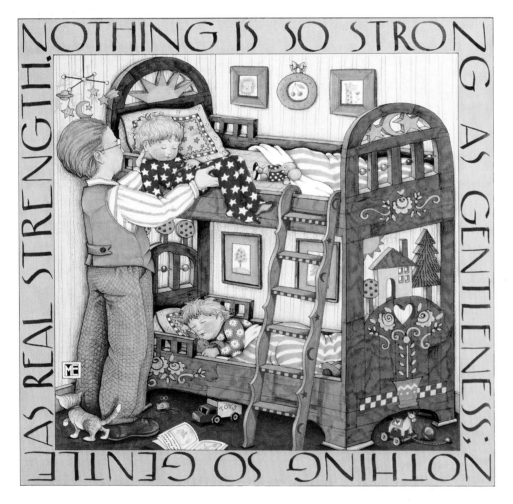

Mary receives hundreds of letters each week, from fans age eight to eighty. Excerpts from a handful of letters are reprinted on this page.

Dear Mary Engelbreit,
I had heard of you before, but I dident know you that well. But now that I do I love all your work. You tickle my heart and warm my toes.
I Love You,
Krystal

P.S.
Life IS
a chair of
bowlies!

Dear Ms. Engelbreit,
Just a short note to thank you for all of the enjoyment I receive from your beautiful work.
The love you portray in your work of children and family is a great inspiration to everyone.
Thank you,
Debbie

Dear Mary Engelbreit,
This is the first fan letter I've ever written in my 72 years. I want you to know how much your Thank You (A World of Thanks to You) card touched me. The girl expresses so many emotions in me that I wish I'd bought all the store had on display. She makes me want to smile. You are most welcomed.
Sincerely,
Velma

Dear Mary Engelbreit,
...I was wondering, you had a very high dream and standards and you accomplished them. How do you feel knowing you've done so much and are a big role model for girls? Also, some people have always told me that being an artist or a photographer (what I really want to be when I grow up) are very hard and always tell me all the bad things about them, how did you not let those rude comments get to you? Did your mother scold you or support your dream to be an artist?...
Sincerely,
Elizabeth

Mary's knack for capturing the magic in everyday life has led to frequent comparisons of her work to the paintings of Norman Rockwell.

Because her work is personal, Mary shies away from revealing what inspired particular drawings. "I hesitate to explain when people ask, 'What did you mean by this drawing?' or 'What were you thinking of when you did this?' *I* know what *I* was thinking of, but when people buy that drawing they're thinking of something completely different, something that is relevant to their own lives," she explains. "I don't want to ruin it for anybody."

She is also wary of discussing who, in particular, inspired certain drawings, but she does admit that her family members surface frequently. "I think of the kids a lot when I draw," she says. "The drawing may not look like them, but I was thinking about them when I did it. There are symbols of things they like in the pictures. I've used Phil a couple of times, too," she says. "'A Good Husband'—that's Phil."

Mary's mother admits to seeing herself in a few drawings, too, and thinks she can trace some drawings to specific moments from Mary's childhood. "She has a picture of a mother hanging a picture in the living room," she says. "I remember one time when Mary was about five. We had moved into a new house, and it had this awful wallpaper. It was shades of blue in a huge diamond pattern. Mary did an oil painting for the dining room to go with this awful diamond pattern. Of course, I hung it on the wall because she had made it for the house. I think of that sometimes when I see that picture."

Mary's father died in 1990, but he lives on in Mary's work. "'I Love You, You Old Bear,'" Mary's mother says in reference to one of her daughter's illustrations, "she did that for him, and 'My Hero' is another she did for her father. He was so proud of her. I'm sorry he's not here to see her success."

Mary's knack for capturing the magic in everyday life has led to frequent comparisons of her work to the paintings of Norman Rockwell. Mary is flattered by the comparison, but is quick to qualify it. "It's nice," she says. "But I think it's because of the subject matter, because God knows I'm certainly not in the same league as far as ability."

By 1985, greeting card buyers weren't the only ones taking notice of Mary's warm and homey illustrations.

56

I Love You, You Old Bear,
1984 (right)
My Hero, 1987 (below)
Inspired by the artist's father.

Greeting card companies started paying attention, too. It didn't take long for a couple of good-sized ones to approach Mary about an exclusive contract.

For Mary, the timing couldn't have been better. "It was getting so big," she explains. "The distribution was becoming a nightmare, and we decided that either we were going to have to get even bigger and borrow a ton of money and really get into it, which I absolutely did not want to do, or we could assign the rights to someone else. I didn't want to spend my time managing inventory; as usual, all I wanted to do was draw. So this was the perfect opportunity for me."

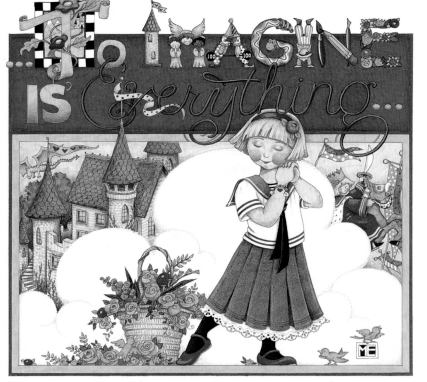

The decision was not an easy one for Mary. Her prior experience with card companies had left her frustrated at the lack of control over her own work. She worried about getting lost in the bureaucracy of such a big company, and ultimately, Mary

chose Sunrise Greetings, the smaller of the two companies courting her. "I was afraid they would make me draw things I didn't want to draw," she remembers. "So I made it very clear that that wouldn't work." Wisely, the company agreed to Mary's terms and signed her to a long-term contract. The relationship brought Mary increased exposure and allowed her to concentrate on drawing full-time. And the company? "They *were* a small company," says Mary with a smile. "They're big now."

Over the next several years, The Mary Engelbreit Company, which had enjoyed steady growth since its founding, got big too. With the greeting card business well established and in the hands of Sunrise, Mary and Phil turned their attention to other outlets for Mary's art. Calendars, T-shirts, mugs, address books, stickers, magnets, gift wrap, rubber stamps, and ceramic figurines would all follow, along with clothing, wall coverings, playing cards, gift books, and more than three hundred other products. Mary employs several designers who help transfer her work to the various products, but she is the sole creator of all the original illustrations.

Success breeds opportunity, and in 1993 Mary, at long last, got the opportunity to illustrate her first children's book. More accurately, she *made* the opportu-

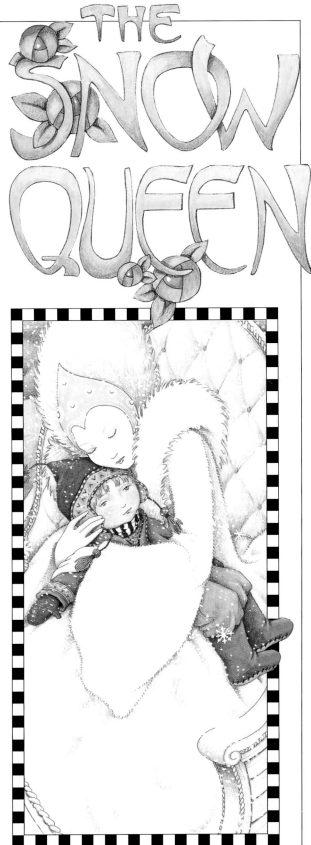

THE SNOW QUEEN

nity for herself. One of Mary's favorite fairy tales as a child was Hans Christian Andersen's *The Snow Queen*. She'd always dreamed of illlustrating it.

"I think it was my favorite because a little girl is the star of the show," Mary explains. "In most fairy tales, the girl sits around waiting for her prince, but in this one, she goes out to rescue her friend. I loved the way she just kept plowing ahead, having all these adventures."

Mary tried twice to convince a publisher to produce a new version of the nineteenth-century tale with her as illustrator, but she found little interest. Undaunted, she plowed ahead. "I finally said, 'I'm going to do this on my own. If somebody wants it, they can buy it, and, in the meantime, I'll have fun doing it.'" (The analogy here should be lost on no one.) After the publishing company saw eight illustrations Mary had drawn for the story, it suddenly became much ·more interested. This story, of course, has a happy ending. The book was published and became an immediate best-seller.

Realizing her childhood dream was an eye-opener for Mary. "It was fun," she says of book illustration, "but, oddly enough, I think I like doing cards best."

She explains: "Illustrating *The Snow Queen* was the hardest thing I ever did. For twenty years I've never had to make people look the same from one picture to the next. It's really difficult. You've got to keep reading the story to make sure the clothes in the illustration are consistent with the text. The girl in *The Snow Queen* changed clothes several times during the book. And if she gives away a scarf, or if she loses her pair of shoes, you've got to make sure that in every picture you've got all of that right. Children really notice those details. I know I always did."

Although the task is arduous, fans will be relieved to hear that Mary would not mind giving book illustration another shot—when the time and the project are right. "I would like to do another book when I don't have anything else to do because it's a year out of your life," she says. "It takes a long time to do it right. I would like to do a nursery rhyme book, which would be a little bit more like greeting cards." And don't doubt that one day Mary will tackle her all-time favorite book. "I would *love* to do *Jane Eyre*," she says enthusiastically.

It would surely be worth the wait.

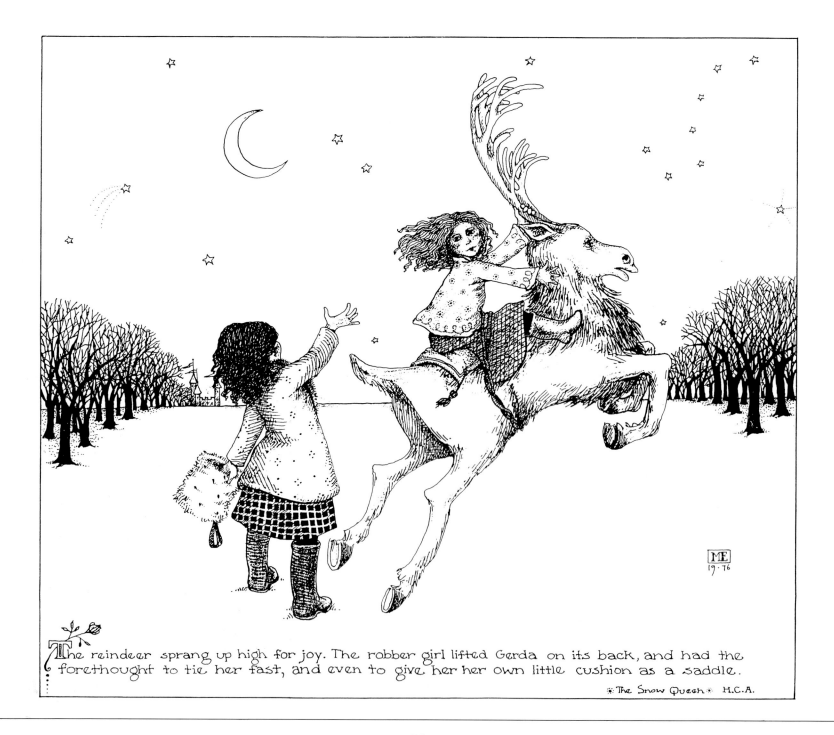

The reindeer sprang up high for joy. The robber girl lifted Gerda on its back, and had the forethought to tie her fast, and even to give her her own little cushion as a saddle.

The Snow Queen · H.C.A.

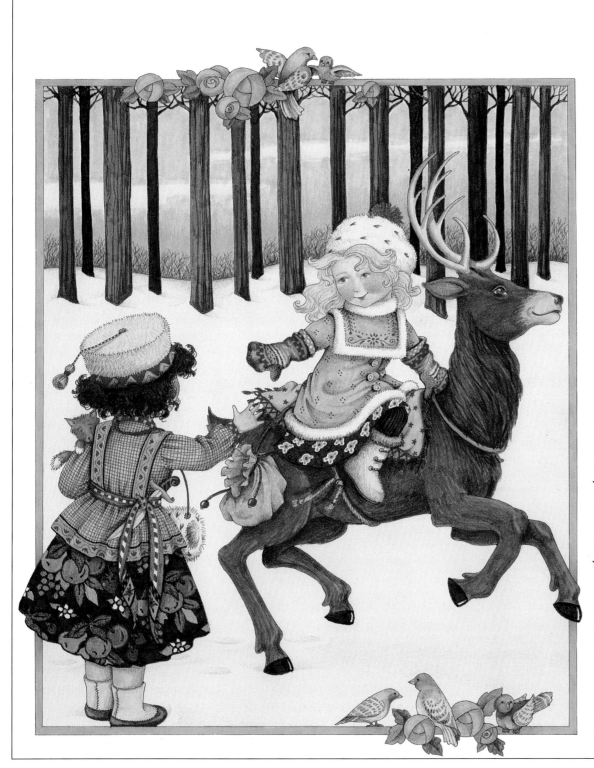

The Snow Queen, 1976 (opposite)
The Snow Queen *by Hans Christian*
Andersen was Mary's
favorite fairy tale as a girl.
As a young artist she'd always dreamed
of illustrating it, and, in fact,
she often drew her favorite scenes
from the book just for fun.
The drawing on the opposite page
was done in black ink in 1976.

The Snow Queen, 1993 (at left)
In 1993, The Snow Queen *illustrated*
by Mary Engelbreit, became an
immediate best-seller.
It was Mary's first children's book
and the realization of a life-long dream.

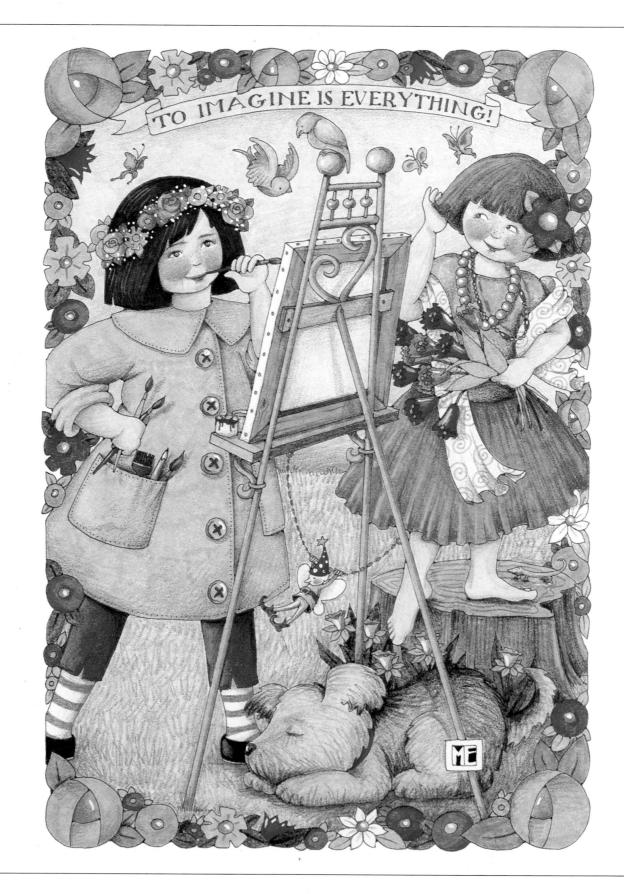

To know is nothing at all;
To imagine is everything.
—*Anatole France Thibault*

To Imagine Is Everything

What is it about Mary Engelbreit's drawings that moves so many people in so profound a way? What magic lies inside these colored-marker-and-pencil illustrations? Mary is likely to shrug off such questions out of modesty, but when pressed, she offers this answer:

"Well, I've always figured that since I'm illustrating things that happen to me in my regular, old, everyday life with my friends and my husband and my kids, as well as with my mother, my sisters, and my family, they are things that every person has had an experience with one way or another. Everyone has friends or family, so everyone is bound to recognize *something* in what I draw."

Mary also feels that the prevailing social context probably contributes to her popularity. "If you listen only to the news, the world seems like a pretty scary place." she says matter-of-factly. "I think people are looking for a bit of normalcy. I think they're looking for something safe and comforting, and they see it in the drawings. People tell me that the cards are a relief to them. One woman at a signing told me that when she feels down she comes into our store and just looks at all the cards and that they make her feel better."

According to Phil, the popularity of his wife's work is the result of a harmonious union of three forces. "It's the themes she chooses, the words she uses, and the artwork that holds it all together," he says.

It begins with the themes she chooses. "In some ways a lot of her things express love," Phil says. "And they

express friendship, which is, I think, why she's so popular among women, because women are much better friends than men are. When you combine those themes of friendship and love and family with the words that she uses and the way that she renders her art, it just hooks people," he explains. "Mary is a very good illustrator. Her illustrations are exceptional, but there's more to her popularity than just nice pictures. Mary's artwork is a vessel—a very attractive vessel—that carries something even more important—the powerful themes of love and friendship."

"Her work speaks to people on a very emotional level," Phil continues. "I said something once, in one of my corniest moments, but I think it's true. 'She speaks to us and for us.'"

Greg Hoffmann, a longtime friend of both Phil and Mary and CEO of The Mary Engelbreit Company, also sees Mary as, above all, a communicator. He has known Phil Delano since their college days in the '60s and, through Phil, met Mary in the mid-'70s.

Hoffmann has served as legal counsel and business consultant to the Mary Engelbreit Company since its inception. In early 1995 he officially joined the company on a full-time basis, leaving behind the successful law firm that he helped found. Obviously, he puts much faith and personal stock in the Engelbreit magic.

"We've never done any real research on any of this," Hoffmann says. "But shortly after I joined the company full-time, we gathered all the employees together and considered these questions: 'Who is Mary Engelbreit?' and 'Why do people like her?'"

The answers didn't surprise anyone. "One thing that they like about Mary is that she speaks for them," he says. "Mary is them. Mary *is* our customer." Hoffmann continues, "Mary is a messenger. That's the way I express it. Mary heard me say this once and told me I was getting a little carried away. But in my opinion, that is what draws people to Mary Engelbreit. They see a message. So Mary is, in many respects, a messenger. Mary speaks for a large segment of people, mostly women, but some men, and she speaks in different ways to them because her artwork expresses her life, and not just her life but her dreams of how life should be."

Hoffmann is quick to cite examples

from Mary's portfolio. "'This Woman Deserves a Party,'" he says in reference to an Engelbreit classic that has heralded countless baby showers since Mary created it in the early 1980s. "I don't know that there's any woman in the United States, in the world maybe, who's been pregnant and hasn't felt like that. I mean, my wife was that way. If you went and polled the women in your company, they'd all go, 'Yeah! Throw me a party! I definitely deserve one!'"

According to Hoffmann, Mary is able to speak to people on a very human level because "she's just a regular person like everybody else. She's not perfect. Occasionally, she fights with her husband or gets mad at her kids, but her artwork expresses how we'd *like* to be. And at the same time, there is a wit and a touch of cynicism and a humor in her work that says, 'It's okay that we're not *always* this way. It's okay that we're not perfect.'"

He offers another example. "You know, one of my favorite drawings is 'Save the Whales.' We all want to save the whales. I mean, everybody wants to do the right thing for the environment, and we all hurt when we see oil tankers destroying some beautiful coastline. To see all that wildlife destroyed is just terrible. I look at this particular drawing, and what do I see? It's a little girl pasting whales in her scrapbook. She's saving them. To me that was just like—boom!—that's right! We all want to do the right thing, but Mary just gives it that little twist. She brings a little levity to serious subjects, and it makes her message even stronger."

The secret to Mary's appeal? Perhaps her mother captures it best. "She creates things that touch your heart," explains Mary Lois. "Her drawings have that nice quality. Crudeness and vulgarity hit us in the face every day. Mary's pictures capture something we love and are losing fast."

THIS WOMAN DESERVES A PARTY.

Where do you get your ideas?

Composers, sculptors, writers, painters—anyone who's achieved success through creativity has been asked the question. The more creative and original the work, the more urgent the inquiry becomes.

Mary Engelbreit has been asked this question often enough that she has a one-word reply at the ready. "Shopping," she says, straight-faced at first, but then with a smile that belies the inherent difficulty in describing such esoteric and personal forces as inspiration and creativity.

Still, Mary is only half-joking when she offers her glib reply. She explains: "I go to the flea markets. I'll walk around and just look at stuff. I can get an idea from seeing a piece of pottery. Or I'll see a pattern on a piece of china that I like, and I'll think of a drawing. It leads to an idea. That design will end up on a little girl's dress or something."

Inspiration can also strike while Mary wanders the aisles of a children's bookstore or even as she drives around the neighborhood. "I think of a lot of things while driving," she says. "Sometimes I just get in the car and drive. It sounds strange, but it helps to clear my mind."

Although she does occasionally get stuck for ideas, inspiration has never been much of a problem for Engelbreit. Usually, she need look no further than to her own two sons, her husband, her friends, or back to her own childhood. The ideas, she assures, just keep flowing. "Especially from my kids," she says. "When they're playing at the beach or in the yard—it's just there. Or the neighborhood where I used to live—we used to have a little Fourth of July parade, things like that. I guess I do see things."

Even if Mary takes for granted the flow of ideas, those who work closest to her constantly marvel at her ability to continuously generate meaningful illustrations and to see the world with new eyes.

Stephanie Barken, Mary's longest tenured employee aside from her sister Alexa, speaks of her friend and boss's perceptiveness with a measure of awe that borders on disbelief. "I feel like I'm blind to half the world when I'm with her," she says. "She's so perceptive. She absorbs so much. Maybe that's the secret to Mary's success; she absorbs so much, she has so much to draw from. I think she just sees so much more than other people see. She really takes in everything, and it very definitely comes back out in her artwork."

Barken's admiration is matched by that of another longtime friend, Bev Vogt. "To walk with her through a store or even to drive through the country with her is so amazing," says Vogt. "She has an incredible eye for detail. It's almost intimidating, because her mind is moving so fast. She's making so many observations. She might see a cute house, and she'll store it away. Later, it will come out in her work, and it's always exactly right. She gets it so right. I don't know what you call that. Genius? She's one of the smartest people I've ever known."

Hoffmann believes that Mary's gift lies more in seeing "differently" than seeing "more."

"Mary is a person who, I believe, has a different perspective," says Hoffmann. "It isn't necessarily that she takes in more information, but she processes it in a different way, and she views things in a different way than you or I or the majority of others. It's not necessarily that she sees things that others don't see, as much as she sees them in a different light than others see them."

Mary respectfully denies her friends' claims that she possesses superhuman powers of vision and retention, but she does admit to being keenly aware of the world surrounding her, particularly from a visual point of view. "I am a very visu-

ally oriented person," she says. "When I'm looking at a sunset, I'm thinking 'How would I draw that? What colors would I use?' I get a million ideas just looking around me. I think everybody notices those things, but I think that because I have a reason to remember it—hopefully I'll be able to use it later—that I do. Besides, I just love *things*! All the great design in the world—I never get tired of looking!"

However powerful Mary's visual perception, discussion of her work from a purely visual point of view would be incomplete. The words that the drawings are often built around, whether she writes them herself or borrows them from somewhere else, often add an entirely new level of appeal and emotion to her drawings.

Even though Mary identifies herself as an artist, never as a writer, she is keenly aware of the importance of the words. "People like the drawings," she says. "but I think they respond to the words and the situations. They'll tell me that a card said exactly what they wanted to say."

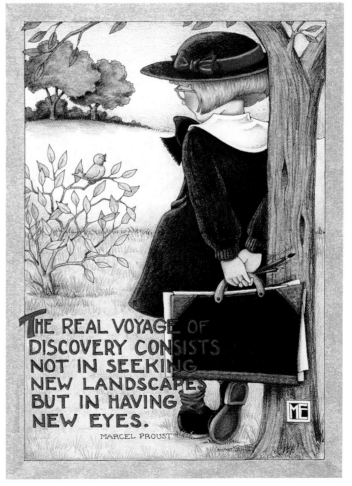

THE REAL VOYAGE OF DISCOVERY CONSISTS NOT IN SEEKING NEW LANDSCAPES BUT IN HAVING NEW EYES.
MARCEL PROUST

Mary appropriates her quotes from a variety of sources—vintage quote books, children's and women's magazines from the '20s and '30s—even the Bible has been a source for just the right phrase. But perhaps the most personally satisfying and often the most humorous quotes are those spoken, or misspoken by people Mary knows.

"Life Is Just a Chair of Bowlies" is the most well-known example, but there are many others. One of Mary's personal favorites came from her youngest son, Will. On a particularly hectic day, Will, then eight years old, attempted to comfort his frazzled mother by saying, "I know, Mom, you just want a little piece of quiet." The malaprop was immortalized by Mary and has since entered the lexicon of fans everywhere.

Mary vehemently protests being called a writer. But she has "come up with" (she's hesitant to even use the word "written") several of the sentiments that appear on her cards. Whether her phrases consist of one word ("Believe") or more ("Time Flies Whether You're Having Fun or Not!"), they belie the heart of a writer, or at the very least, that of a complete and profi-cient communicator.

Her original quotes display Mary's sharp sense of humor at its brightest. A mischievous little girl with one raised eyebrow holds a cute-as-a-button tray overflowing with strips of paper inscribed with the names of various professions: nurse, librarian, lawyer, mother, dancer, etc. Stuck in their midst is a placard with the word, "LIVES" and underneath, in bold letters, the injunction, "GET ONE." Loaded? You bet. Traceable to a specific person or incident? Most likely. Cute? Well, yes. Improbable as it may sound, considering its pointedness, Mary manages to make the message irresistible.

Another card that Mary drew in 1995 perfectly captures her independent nature. A freckle-faced, flaxen-haired girl in overalls and a straw hat chews a piece of wheat—her feet up on a desk (or is that a drawing table?). The caption: We Don't Care How They Do It in New York.

Did any *particular* New York resident or company inspire this little gem? Mary would just smile at the question. And to be fair, she says, she thinks she saw that line on a button somewhere. Even so, with this fresh-as-Iowa-corn drawing, she has made the line her own.

When asked what about her would most surprise her fans, Mary searches for

the right words, but you get the sense that she already knows the answer. "Well," she says, "I think I'm a lot more . . . I'm a little more . . . a lot of people think I'm like the cards. They think I'm sweet and nice and cute. They think I'm really sweet. I'm not. I guess that would surprise them. They think I'm sweeter than I am."

Can this be? Mary Engelbreit *not* sweet? Mary's mother laughs about this and explains that if her fans judge Mary only by her illustrations, the image would be impossible to live up to. "I think they have her on a pedestal," she says. "They think she's a saint, but she's not, and she knows she's not. She can't be all things to all people, but she is very generous and thoughtful. She does a lot of good in the community but in quiet ways. She doesn't like to draw attention to herself. She's also very gracious. I'm always dragging people who want to meet her into the studio, and she's so good about it. She says, 'Sure, Mom,' and she greets them all like friends."

Perhaps because Mary's internal compass has always indicated such clear direction, she does sometimes grow impatient when others don't seem to know where they're headed. Mary's mother holds up her daughter's "Lives: Get One" illustration as an example of this tendency. "Now, that speaks vol-umes of Mary," she says. "She can be somewhat intolerant of people who don't get up and go and do what they're supposed to be doing."

Mary confesses to the charges of impatience and *occasional* snippiness. But after all, she is a real person. "Sometimes I can be a little cynical," she admits, "but I hope in a funny way. I enjoy humor with an edge to it, but I don't like it when it becomes hurtful."

"People see her at a signing or at a public appearance, and she's wonderful and warm," says Hoffmann. "But that's in a different kind of social context. In reality, she's kind of shy and a little reserved, but there is a very, very warm heart there. It's just that it surfaces in different ways, and I think in many ways it surfaces through her artwork. And that's where she ends up speaking for people."

One *can* gain insight into Mary by looking at her cards. Just don't make the mistake of looking at only a handful of them. Each of the many cards she's drawn (Mary estimates about eight hundred) gives a different insight into her personality. Nearly everything that Mary is, is in her artwork—somewhere: the kindness, nostalgia, shyness, nurturing nature, generosity, and optimism, as well as the impatience, occasional snippiness, and satirical attitude.

Mary confesses to the charges of impatience and *occasional* snippiness. But after all, she is a real person.

One of Mary's pet peeves is the tendency of people to write off her work as one-dimensional or sum it up in one word. More often than not, that one word is *cute*. Mary knows full well that cute is the first word most people arrive at when describing her drawings, and she doesn't deny its validity. In fact, she realizes that if anyone's to blame for perpetuating what one newspaper referred to as "the cult of the cute," it's she.

In the early '90s Mary designed a logo for her retail stores. It features the Engelbreit icon, Ann Estelle, complete with eyeglasses, wide-brimmed hat and prim sailor suit. A background banner proclaims, "Engelbreit's the Name. Cute Is My Game."

Cute, indeed. But, for an illuminating glimpse into the inside world of Engelbreit's empire (and into her sharp sense of humor), flip over the business card of one of Mary's employees. The slogan on the back is the same, but in this version, a decidedly more relaxed Ann Estelle slouches forward in a wooden chair. The spectacles have been replaced by shades. The hat is kicked back on her disheveled head. She holds a drawing pen in one hand and a beverage can in the other. Her skirt is hiked up in a less-than-lady-like fashion, and a cigar is clenched in her teeth. It's a rendering of Ann Estelle that won't ever be printed on pillowcases, and it's Mary's way of winking at the kingdom of cute that she has created.

"My artwork *is* cute," she admits. "It is. But I think some of it is funny, too. There's a little edge to some of it—I don't think it's all cute. Some of it is; okay, most of it is, but not all of it."

"Say it loud!
We're Cute and We're Proud!"

—the unofficial motto of The Mary Engelbreit Company

Make the Most of Yourself

When Mary is inspired by one of her vintage books or magazines, a misspoken aphorism by her children, or a stroll through an antique store, once she hits upon an idea for a drawing, she moves with the surety of a veteran and the enthusiasm of an ingenue.

Typically, she sits down to draw in the evening after dinner. Mornings are reserved for meetings with her staff. Afternoons are for shopping and running errands, and early evenings are spent with family. She claims that she can't draw before noon. Working until 2:00 A.M. is not unusual.

Mary simply loves to draw. She swears that if she never made a dime from her work, she would be just as enthusiastic. To listen to her discuss drawing, you would never doubt her. Her tone is equal parts excitement and reverence with a healthy dose of wonder thrown into the mix.

"The major pleasure for me is just the act of drawing," she says. "I just can't describe what it's like. I've tried to describe it to Phil, and I can't. It's so satisfying to draw—to have something in your head and then put it down on paper."

Even as she speaks of drawing, she becomes flushed with excitement. "The whole time I'm drawing, the minute I put something on paper, I'm making one decision after another—it's so interesting! To leave that line in, to take it out, or to move it over here, to change this color—it's just the most satisfying thing I can possibly think of doing. And," she

says, pausing to take a breath, "when it all comes out right . . . when you know you didn't put a line in the wrong place, you didn't make a mess of the color, which happens a lot, in my opinion—when everything comes together and it looks *right*, I don't know why, but it's very satisfying." Another pause and she continues, "And to be able to make a living doing that is just . . . Well, I'm just so fortunate. It's great."

The pleasure she derives from drawing is so great, in fact, that she almost feels *guilty* for experiencing it. She worries that some people will *never* experience such an all-encompassing sensation. "It's such a wonderful feeling," she says. "I know it's ridiculous but I think, 'What do people *do* if they don't draw?' Of course, they probably have their own thing, something completely different, but what if they don't? It's just that I want everyone to feel that marvelous sense of contentment at least a few times in their lives."

Mary says she's only talked to a few people who feel the way she does about what they do, but she cites a book that explains the experience perfectly. "It's called *Flow: The Psychology of Optimal Experience*. The author calls that feeling *flow*, and he describes it perfectly—you lose track of everything, and you're so concentrated on what you're doing that time disappears. It's such a fantastic thing! So, I'm relieved to know that plenty of people have it."

For Mary, flow, which carries with it feelings of discovery, enchantment, creation, freedom, and control, has been drawing's gift to her all her life. "I've felt like this about drawing as long as I can remember," she says. "I can remember when I was little, I had a window in my bedroom with a wide sill. I'd pull a chair up to the sill and draw what I saw out the window or what I imagined I saw. I remember thinking it was a pretty perfect way to spend an afternoon. I was thrilled doing it then, and I'm thrilled doing it now."

Creating a card, from idea to finished art, typically takes Mary from two to five days. There are no thumbnail sketches or character studies, no practice runs or false starts. What she starts, she almost always finishes. And when things go right, as they usually do, she starts and finishes the drawing process on the same sheet of paper. "The reason I don't have many sketches of my finished pieces," she explains, "is because I do it all on one piece of paper."

It's a method that works for her, but she doesn't necessarily encourage it. "I always felt like every single thing I did had to wind up a finished product," she says. "I don't think that's a good thing." Mary's hesitant to give advice, but this is one tip she doesn't mind passing on to would-be artists: "Experiment," she says. "Be adventurous. Try a lot of different things. Who cares if it doesn't work out? It's only paper!"

Mary begins with a pencil sketch, using an 8H drawing pencil and erasing misdrawn lines along the way. Once she's satisfied with the pencil sketch, she begins to draw in the line work in black ink. After the sketch has been inked in, she erases the pencil marks and moves to the coloring stage.

While working on the pencil sketch,

Mary strives to keep interruptions to a minimum—another reason she prefers to work at her home office and often late into the night. "I really like to have everything quiet when I draw," she says. "I don't like to be distracted."

When she gets to the marker-and-colored-pencil stage, the need for extreme concentration is lessened and the music usually comes on. Sometimes she'll even watch a rented movie. "Unfortunately," she says with a smile, "my eyes are getting so bad now that I'm older, I have to wear a different pair of glasses to draw with, so I can't actually *see* the TV, but I can hear it."

She uses markers to lay down the "flat," or base, colors. "I have every single marker that's ever been made," she jokes. "And I have to have them all in front of me to be able to work."

After she's colored in the drawing with markers, she

75

When she's drawing, Mary imagines the scenes and the characters, bringing them to life in her head so they'll be more interesting on paper.

moves to the colored pencils. "Any shading you see is pencil," she explains. "Everybody thinks it's paint, but I can't paint. Actually," she continues, "people are horrified when they find out that I use markers. Markers are awful—they fade. But you get such instant results!" Fortunately, she says, marker technology is getting better, and spray fixative helps them to hold their color longer.

When she's drawing, Mary imagines the scenes and the characters, bringing them to life in her head so they'll be more interesting on paper. She points to her drawing of an awkward, innocent kiss by a young couple, and explains: "I'll have the scene in my head of what I want to draw: kids kissing at the front door. I think of what kind of people they are, where they live, what they like to do—things like that. Not only does it help to pass the time, but it all goes in to what they turn out to look like. I like to make them all look different. I know I'm insane, but I think of them as all having different little lives, and I want the personality of each character to come through. Sometimes I do that through the situation and sometimes I can communicate a figure's personality by the look on his or her face." She points back at the drawing on the wall and shares a little inside information: "This is the front porch from our old house."

When Mary is at work on a drawing, there is nothing she'd rather be doing. "Especially if I'm working on something I really like," she says, "I don't want to go out. I don't want to sleep. I wish I could say I don't want to eat, but I do want to eat in a big hurry and get back to work. I hate to stop till it's finished."

In fact, it's even hard for Mary to enjoy a vacation if it keeps her away from her work for more than a week. "I don't like to be away for too long," she says. "One of the reasons is that when I'm away in a new place, I get a lot of ideas for drawings. I see a lot of new things, or I just start thinking differently because I'm in a new place. I get a lot of ideas, and I want to get back home and get to work on them. I feel like I have to get into the studio, or I'll miss the moment."

She's tried bringing her art supplies with her when she travels, but that's proved to be unmanageable; she likes to have her entire marker set and her reference material at the ready when she draws. She does write down ideas and takes them home to work on but contends that something is always lost in the lapse. "When I'm really excited about it, I just want to sit down and do it," she explains passionately. "I feel like I get a much better drawing than when I try to dredge it back up three weeks later."

Bee Good, 1996
At left is the pencil sketch of a greeting card cover, and above, the finished illustration. Because Mary draws her illustrations start-to-finish on the same sheet of drawing paper, very few pencil sketches of her art exist.

How Kind you were to open the Gates
of Heaven and give me that
little glimpse of Paradise.

Gates of Heaven, 1996
*The pencil sketch at right has been
partially inked by the artist.
The finished illustration
is shown above.*

How Kind you were to open the Gates
of Heaven and give me that
little glimpse of Paradise.

Make the Most of Yourself, 1996
*The sketch at left has been fully inked
and is ready to be colored. Mary will
use colored markers and colored pen-
cils to finish the piece (shown above).*

Cherries, checks, and cottage roses; straw hats, eyeglasses, vibrant colors, quotes, and decorative borders—all are standard elements of a Mary Engelbreit illustration. All of these elements, and many less tangible ones, work together to create the Engelbreit style.

Mary Engelbreit's style is probably more widely recognized than that of any other contemporary illustrator. Millions of fans and collectors around the world know Mary through her cards, books, and decorative products, and many more people, who may not know her by name, are familiar with her work.

Her phenomenal success has, of course, bred imitators. The imitation can be subtle, like the use of a decorative border, or more blatant. Her company was recently forced to take legal action against a woman who was painting Mary's designs on tables and chairs. Mary's personal style is under siege by countless imitators looking to capitalize on her popularity.

"I've been told by other artists that greeting card companies will hand them a stack of my cards and say, 'Here. This is what we want.'" she says. Not surprisingly, experiences like this leave Mary feeling somewhat violated. "To me, the drawings are very personal, and they hold a great deal of meaning," she says.

"Frankly, having someone or some company try to cash in on the successful end of twenty years of hard work is, to say the least, extremely annoying."

Phil understands how these incidents affect his wife, perhaps because he sees firsthand how much thought Mary puts into her work. "Her drawings are really her way of expressing herself," he explains. "She's shy and introverted in some ways, and a lot of her feelings and personality come out in her drawings. Many people don't realize that she thinks very hard about what she does before she does it. She's not just knocking these things out one after the other."

Protecting the sanctity of Mary's personal style is a tricky business, and the more popular her work becomes, the greater the challenge. "I don't own cherries and I don't own checks, so there's not a lot we can do if people use those elements," Mary explains. "But if it's close enough to be confused with my work in the marketplace, we can do something. We've seen people who put out cards in a style very similar to mine, even signing their initials like mine. One woman's name was Mary something, and she wrote her name in a box exactly the way I do my initials," Mary says incredulously. "This is getting to be a constant thing; it can be very frustrating."

Knockoff artists are more than just frustrating to Mary's artistic integrity. According to Phil, the real danger is that Mary loses control over the quality image that they've cultivated for so long. "We really want to provide high-quality products to our customers," explains Phil. "Some people are doing knockoffs of Mary, and they just aren't made very well. They say it's flattering to be imitated, but if the fake doesn't look good, and people assume it is Mary's work, it's really damaging."

To protect the integrity of Mary's artwork, Phil, Mary, and Greg are very particular about what consumer products it appears on. Without question, The Mary Engelbreit Company has embraced licensing as a way of spreading the Engelbreit message and as a way of making a profit. "It's nice that an artist can make money since 95 percent of them don't make a dime," says Phil. But short-term gain at the expense of long-term deterioration of the Engelbreit image is contrary to the company's business plan. "I'd like to create something that's kind of timeless," says Mary. "My hope is that my children could keep this business going after I'm gone."

As an omnipresent reminder of its direction, the company has adopted and illustrated a mission statement.

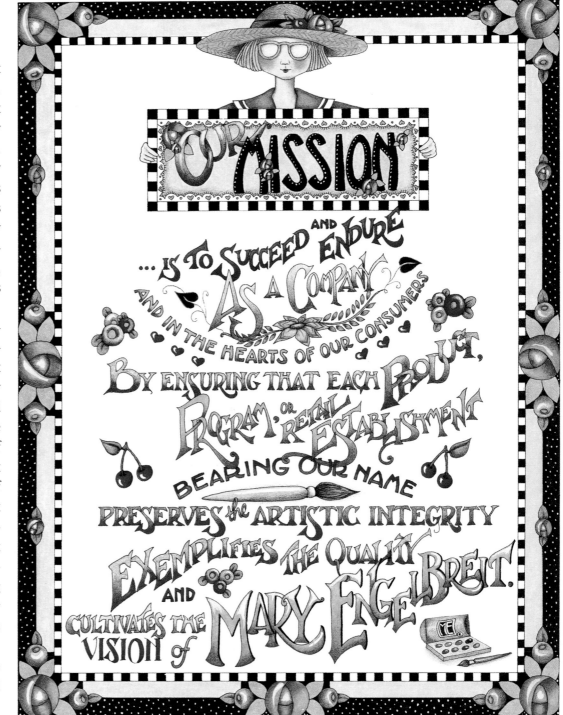

OUR MISSION ...IS TO SUCCEED AND ENDURE AS A COMPANY AND IN THE HEARTS OF OUR CONSUMERS BY ENSURING THAT EACH PRODUCT, PROGRAM, OR RETAIL ESTABLISHMENT BEARING OUR NAME PRESERVES the ARTISTIC INTEGRITY EXEMPLIFIES the QUALITY AND CULTIVATES THE VISION of MARY ENGELBREIT.

The Engelbreit Company is very wary of inferior or "schlocky" products and will work only with first-rate manufacturers. It turns down countless licensing opportunities each year and will terminate a licensing agreement if a producer doesn't pay close enough attention to quality.

Phil relates an experience that sums up the company's commitment to quality. The Mary Engelbreit Company was approached by a reputable manufacturing company that wanted to produce a line of ceramic ornaments, dolls, and figurines. After the deal was struck and beautiful prototypes had been approved, the producer's sales representatives balked at selling such high-end products. Unbeknownst to the Mary Engelbreit Company, the finely sculpted, hand-painted renderings of Mary's designs that were promised were produced at a much lower quality.

Phil vividly remembers seeing the finished product and even now nearly erupts at what he saw. "The figurines were glued to the base with a great big glob of glue as if someone had applied it with a spoon . . . splop! . . . stuck the leg of the figurine in it, and said, 'Next!' Legs were broken. Arms were cracked. The company had produced $300,000 worth of these disasters, and we had advertised the whole program in advance for Christmas. We had printed fifty thousand catalogs featuring the prototypes. But we said, 'There is no way we are going to sell this.' The manufacturer said, 'Okay, we'll sell it in the Orient,' but we wouldn't let them do that either. We made them give it all to a charitable organization. We ended up taking a financial bath on the deal, and so did they. But I guess what I'm getting at is that the integrity of the Mary Engelbreit product line remained intact."

Merely to succeed in business is difficult enough. To succeed while maintaining integrity, heeding a vision, and having fun is more tricky still. It's a precarious balancing act, especially in a business that has grown as fast as The Mary Engelbreit Company. The company faces the challenge with a surprisingly simple strategy. Hoffmann sums it up well: "I always believe that if your goal is to make money, you won't make money. If your goal is to be the best at what you do, whatever that may be, you're going to come out okay. We don't ever want this not to be fun. We don't ever want to lose sight of the message we're trying to send."

"It all starts with Mary," reminds Phil. "She doesn't do this work because she wants to be famous or rich. She does this work because it's what comes out of her soul."

So much of what we learn of love
we learn at home.

Everyone Needs Their Own Spot

The Mary Engelbreit Company is headquartered in a renovated Greek Orthodox church on a wide boulevard in the center of University City, a suburb of St. Louis. Friends jokingly refer to the studio as the "Engeldome" because of its large rotunda.

The major tenant of University City is Washington University, and the community has the vibrant but relaxed feel of a medium-sized college town. Walking down the street to one of Mary's favorite spots for lunch, you'll pass a hardware store, an outdoor fruit and vegetable market, a small jewelry shop, a bakery, a music store, a renovated art deco movie theater, and more than likely, a friend of Mary Engelbreit. The shop and restaurant owners and many of the patrons know her by name—not just in the "she's that famous greeting card lady" way, but often in a "pull up a chair and chat while we eat a salad" way. Everything about Mary is approachable. Everything about her is real. She fits in seamlessly with her neighborhood.

I grew up right around that neighborhood. We called it The Loop, because the streetcar used to loop there. When I was a child, we'd walk over to the movie, and walk home at 10:30 or 11:00—nobody thought a thing of it. It was the first theater that had what they called "washed air." They'd bring in big blocks of ice and blow big fans over this ice, to cool the theater. Mary's father, when he was a young man in school, delivered ice to that theater.
—Mary Lois Engelbreit

A renovated Greek Orthodox church in a suburb of St. Louis has served as the headquarters of The Mary Engelbreit Company since July, 1994. The decor is eclectic, peppered with a spirited mixture of Engelbreit artwork, antique children's books, and lots of Mary's thrift-store treasures. And, although these pictures don't reflect it, with twenty-some employees (and one dog) on site, the activity level is always high.

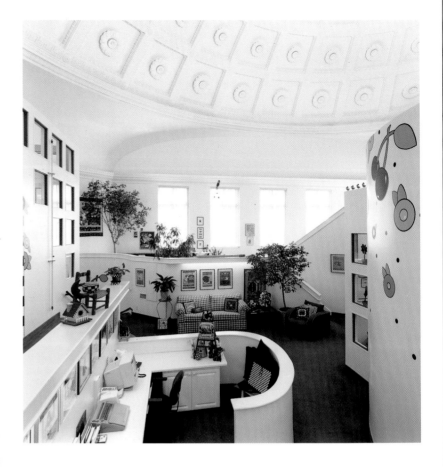

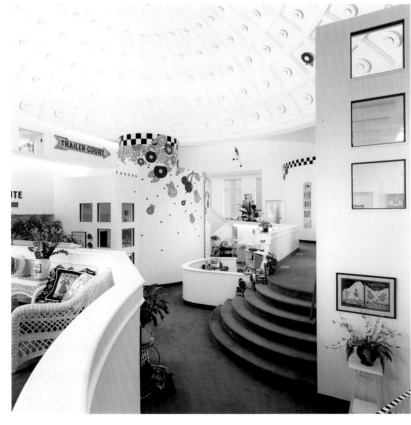

The building's rotunda has earned it the nickname "The Engeldome." Note the single painted flower on the ceiling. According to Mary, they had originally planned to add more flowers, but working on precarious scaffolding convinced them to settle on a "minimalist" look for the ceiling.

Although she maintains a studio at company headquarters, most of Mary's drawing is done at home. Her home studio is set up in an atrium with windows on three sides. A friend painted the trompe l'oeil ceiling to look like open sky above.

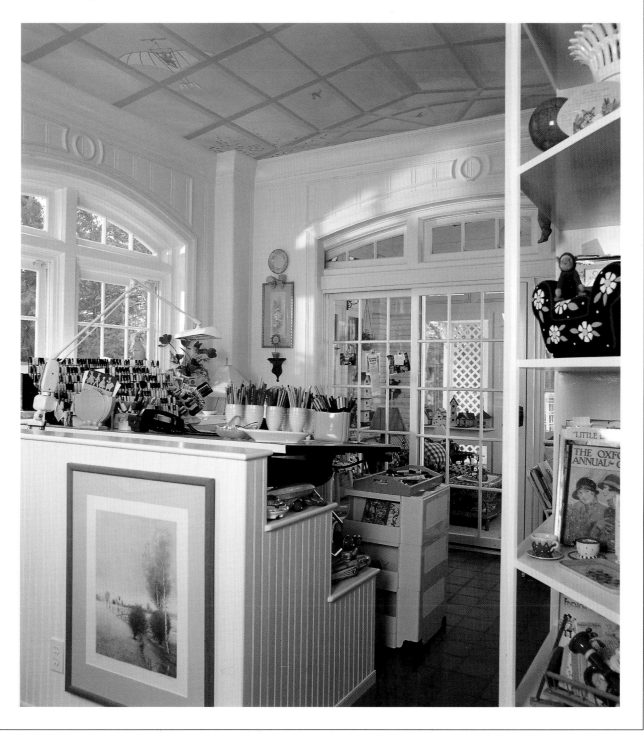

Mary Engelbreit has reached a level of success that would allow her to live anywhere. The nature of her work would similarly put few restrictions on her studio's location. So why not the Caribbean? Why not the breathtaking northern Pacific coast? Why not somewhere a bit more glamorous than St. Louis? For Mary the answer is easy: "My family is here. And all my friends. And

my business." For someone so commercially successful, the order of her reply, though perhaps a coincidence, is refreshing.

Nowhere but in St. Louis could Mary peruse antiques a stone's throw from her first apartment in the Central West End. Nowhere else could she drive past the school where she attended kindergarten, the school that her father once walked to pulling a sled to give Mary a snowy, unforgettable ride home. Nowhere else could she bump into a friend who she's had since grade school, a friend whose baby is Mary's godchild.

Mary's best illustrations are personal. They are about home, family, and friends— all of these things mean St. Louis to Mary. Nearly everything important to her personally, good and bad, has happened within a twenty-mile radius of where she is right now. What's so great about St. Louis? It's home.

YOU AIN'T SEEN CUTE TIL YOU'VE SEEN ST. LOUIS

In the greeting card world, Mary Engelbreit is something of an anomaly. Normally, when you see the work of a well-known artist on a greeting card, it has trickled down from its original medium. Perhaps the artwork first appeared as a book illustration, or even hangs on a museum wall. The five-by-seven-inch greeting-card format, however, has always been Mary's primary canvas, and, on this canvas she has drawn her way to fame.

Mary's art has won her not only fame but also famous fans. Actress Mary Tyler Moore and singers Kenny Loggins and Naomi and Wynonna Judd are among the celebrities who have sent fan letters. Vice President Al Gore used an Engelbreit poster in an environmental presentation, and Mary and award-winning children's book illustrator William Joyce are mutual admirers.

But Mary's favorite "brush with fame" thrill came on a book-signing tour in Santa Fe, New Mexico. She remembers: "I was in a tiny, little bookstore. A really beautiful girl came up with her two beautiful kids and they had me sign a couple of books. She was very sweet. She said, 'I just want you to know that, next to my grandfather, you are my favorite artist and my children's favorite artist.' I asked who her grandfather was, and she said, 'N.C. Wyeth.' I almost fell

out of my chair! That's one of the highest compliments I've ever been paid."

Mary refuses to think of herself as a famous person. "To me, the Mary Engelbreit entity is like a third person," she explains. "Here, we always talk about Mary Engelbreit as this *thing*, as this third person. That's how I think about it."

Still, she admits that sometimes she gets recognized in public. Increased media exposure, coupled with her tendency to draw characters that share her own physical characteristics, makes it possible for sharp-eyed fans to occasionally pick her out of a crowd. She often gets a second look from cashiers when she hands over her credit card.

Mary's two sons have grown accustomed to fielding questions about their famous mom from female classmates. Sometimes, however, the interest is a little *intense*. Mary relates an incident that caught both her and her younger son Will by surprise:

Once when Will was eleven, I went to pick him up at the skating rink. There was a big crowd of kids following Will. Will saw me, and he came running over to the car. He jumped in and said, "Go! Go! Go!" I couldn't go, because there were fifty little girls running towards the car. He said, "Just drive!"

I said, "I can't drive, Will, I'll run over everybody." They all came up to the window and said "Are you really Mary Engelbreit? Is he really your son?" Will couldn't believe it. I think he was somewhat horrified but also pleased to discover he had a built-in way to impress girls. Finally, one bewildered little boy in the crowd brought us back to reality. He said, "What do you do? Who are you?" I said "You wouldn't know me—it's a girl thing."
　　　　　　　　　　—Mary Engelbreit

Lest anyone fear that such incidents go to Mary's head, take heart in the knowledge that her family would never allow that to happen. "Evan and I were at a store in Florida once," recalls Mary, "and I gave the girl my credit card. She got all excited and called to the other saleswomen, who were all oohing and aahing. Then, another saleswoman said, 'This is better than when Bo Jackson was in here last week.' As we left the store, Evan (then thirteen years old) turned to me, rolled his eyes, and said, 'Mom, I hope you know she was just being polite.'"

> **"Mary has friends that she's had for years. That always speaks well of people—having long-term friends."**
>
> *—Mary Lois Engelbreit*

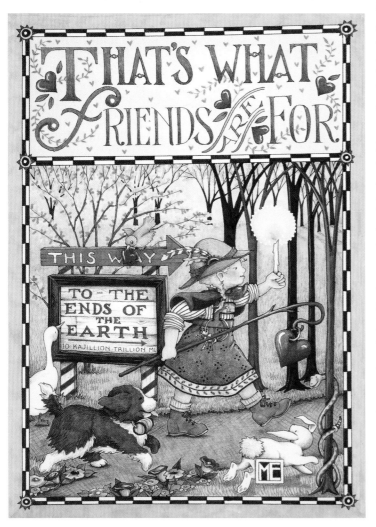

After nearly twenty years of marriage, Phil still marvels at what he calls Mary's "talent for being a good friend." "She values her friendships. She thinks about them," he explains. "I think she takes her friends much less for granted than other people do. She has very intense and long-lasting friendships. She's maintained friendships for twenty-five or thirty years, some even longer! Plus, she's developed very close friendships in the last ten years. She has a lot of real friends, not just acquaintances. I don't keep up with my friends as well as I should. I keep up with a few; she keeps up with ten or twelve."

Many of Mary's friends share her passion for flea-market shopping. The loosely organized collective has inspired a moniker: the Flea Bags. Once a month or so, the group will strike out in search of cast-aside treasures. All are smart and successful professionals, some whose friendships with each other predate their children, husbands, and careers. The shopping expedition ends with lunch or dinner, when the women display their finds of the day and compare bargaining skills. For Mary, the combination of friends and antiquing is an unbeatable form of relaxation.

According to Phil, Mary takes particular pride in selecting meaningful gifts for friends. "She's a wonderful gift buyer," he says. "She buys exactly the right gift for people, and she does it year-round." One friend who has been on the receiving end of several of those perfect gifts says, "She remembers what people like. You may mention that you like something one time, and the item will show up as a gift a year later. Most people don't do that with their own families. She's like that with all of us. It's amazing."

"Mary's really in touch with the kinds of things her friends like," says Phil. "I think that's indicative of the importance she puts on friendships."

When two of Mary's oldest friends, including one she's known since the seventh grade, moved to the West Coast, Mary felt the loss deeply. "It devastated Mary when they moved away," remembers Phil. "It broke her heart, but she has recovered, and still sees them a lot. They visit each other a few times a year."

Mary does enjoy traveling, especially

if it involves seeing an old friend, but St. Louis is the only hometown she's ever had, and she says she'll never leave. St. Louis is all the better for the loyalty of this native daughter. Mary downplays the work she does on behalf of local charities, always opting for low-key involvement whenever possible. She keeps public appearances to a minimum, preferring to lend her time and her work to a cause rather than her increasingly recognizable face.

Not surprisingly, Mary's favorite charities involve improving the lives of children. One such charity is the Girls' Hope organization. Girls' Hope is a special kind of foster-care organization that buys and staffs houses in ordinary middle-class neighborhoods. Girls who have been removed from troubled families are raised in these homes until they are ready for college. It keeps the girls (there is also a Boys' Hope) from being bounced from foster home to foster home. The same six or eight girls grow up together, going to good neighborhood schools and learning what it's like to live in a loving family situation.

Each year, Mary gets hundreds of requests for charitable contributions of artwork and money. Although she is often moved by the worthy causes, she forces herself to concentrate on those charities that she has grown familiar with. "We try to help whenever we can," she says, "but we're only one company and a lot of help is needed out there! Everyone needs to pitch in!"

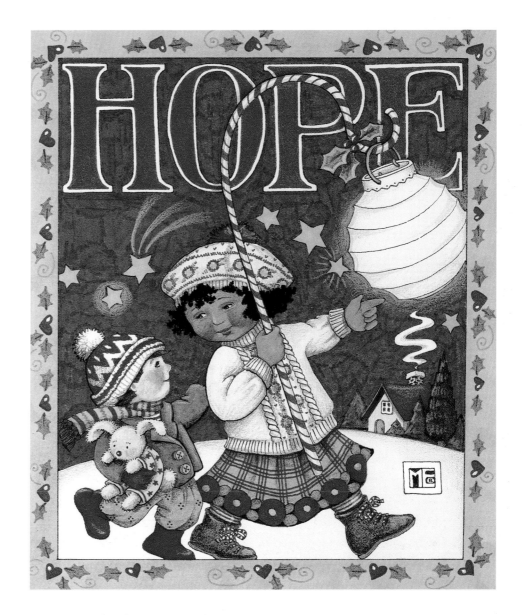

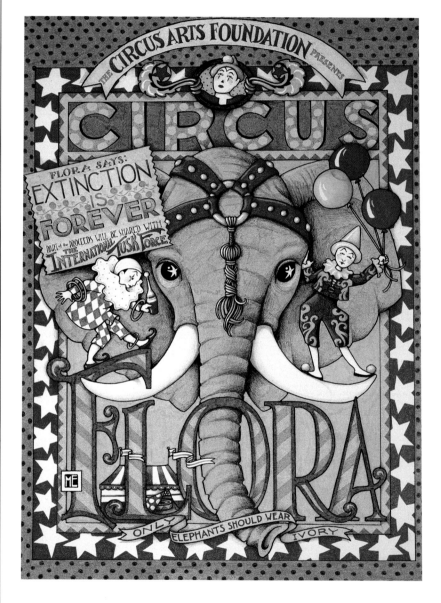

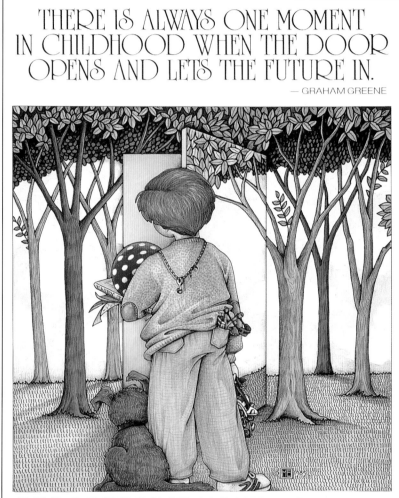

Circus Flora, 1990
Mary drew this poster as a fundraiser for the
Circus Flora, an old-fashioned, one-ring circus based
in St. Louis. The animals used in the show
have been rescued from abandonment or abuse.

Progressive Youth Center, 1985
My husband was a board member
of this delinquency prevention and intervention
organization, and when they needed a poster
to speak to what they do, I came up with this idea.
They used this poster for nearly 10 years
as a fundraiser.

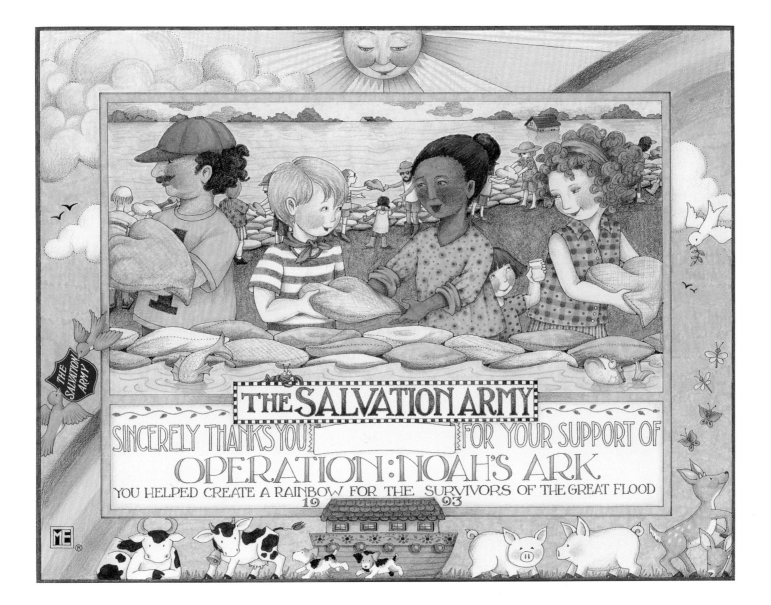

Operation: Noah's Ark, 1993

*The Salvation Army asked me to create a special gift
for all of the wonderful volunteers who gave so much
during the Great Flood of 1993, and I was glad to do it.
I felt honored to be part of such a heroic effort.*

People say, "Don't you want to quit?"
"Don't you want to just travel?"
"Don't you want to do this or that?"
No! I never want to quit!
I don't think I really have a choice.
What else would I do?
I'd go crazy if I didn't draw.

—*Mary Engelbreit*

She Who Laughs, Lasts

For Mary Engelbreit and her company, the future looks much like the present, only more so. The ideas will continue to flow. Mary will continue to draw.

As her sister Alexa points out, "She draws life situations, and life keeps happening."

And what of all the success? According to Alexa, fame hasn't changed her sister in the least. "She just wants to sit back and draw, just like she always has—and she wants everybody else to worry about the business."

Plans are under way to cautiously add more Mary Engelbreit retail stores. "I'd like our things to be even easier to find," Mary says. "I don't want our stuff to be everywhere, but I want it to be everywhere it *should* be, so people who want it will know where to get it."

Mary, Phil, Greg, and the rest of The Mary Engelbreit Company think a lot about the longevity of Mary's work. Although there's no way to predict when public preferences may shift, Greg is optimistic about the future. "I believe there is a core group of people out there who view Mary Engelbreit as a long-term friend and adviser," he says. "Mary Engelbreit is going to be around for several generations, because the message that she sends in her work is universal and timeless. The 'Believe' Christmas card is ten years old now. It's still one of the top-selling greeting cards."

He continues, "We want to be around for a long time as a company.

"In everything we do we want to continue to send Mary Engelbreit's message, and I think that there will always be people who will want to hear that message."

—*Greg Hoffmann*

The way we plan to do that is to ensure that everything we do, whether it's a product, a program, a retail establishment, anything that bears our name, preserves that artistic integrity and cultivates Mary's vision. In everything we do we want to continue to send Mary Engelbreit's message, and I think that there will always be people who will want to hear that message."

Mary's success has afforded her many things. Among the most important, she says, is the measure of control she has regained over her own work. She was willing to pay her dues as an up-and-coming illustrator, but after years of having to produce artwork in accordance with the whim of other companies, she now makes it clear that the dog is wagging the tail, not vice versa. It's a distinction that she says makes all the difference in the world.

"For a while there, I thought, 'Well, I signed these contracts; I have to do what they want. They know what they're doing.' But then I had a kind of epiphany—I realized I was the one with the best understanding of how this business was going to move forward. I had to take control of my business and make sure I was drawing the kinds of things I wanted to draw. Really, the way I work best is when I draw for myself. That's the way for me

and all of our licenses to be successful. I really believe that.

"I feel like drawing is such a part of my life that I have to be in control of it. It is who I am. I don't know exactly what it is, but I feel like my drawings are most successful when I really stick to that personal vision, or whatever word you'd use. Those are the drawings that people seem to identify with the most, and that is what I'm aiming for."

The lesson has been learned over and over: Mary must follow her heart, and the company must follow Mary. "Mary's got a clear vision of who she is and whom she wants to reach," says Phil. "As long as we listen to her and promote that vision, we can continue to give our customers what they want and, we hope, attract new customers along the way."

He admits that they've made some mistakes. "But I've found that every time I've made a compromise or talked Mary into a compromise, I've been wrong, and she's been right," he says.

Mary's belief in her own instincts is tough to undermine. Even as the artistic empire she has built continues to grow, she's philosophical about the sometimes fickle greeting card and gift market. She has no more inclination to try to forecast and cater to the whim of consumers now than she did when she was work-

ing out of a tiny basement studio at the age of twenty-five. Even if buyers did start to reject her style of drawing, she wouldn't change—and couldn't.

"I don't feel a whole lot of outside pressure about the drawings," Mary says. "I know that I can only do one thing. It's not as if I could turn around and do some beautiful landscape paintings or something. This is all I know how to do! Any pressure on me comes from me, nobody else. Maybe when I retire, I'll learn to paint or sculpt, but right now I am so happy to be doing exactly what I'm doing. I'm very glad people respond to the drawings the way they do, and I hope they see the fun that I and, I hope, everyone at our company has producing these things for them!"

Mary Engelbreit didn't sit down at age eleven to plot the strategy that would take her to the pinnacle of success in the illustration world. She just sat down to draw. She drew what she saw around her. She drew what was outside her bedroom window and what was in her heart. It may be hard to believe that the business plan of the woman who sits at the center of a multimillion-dollar industry hinges on this simple a philosophy, but it's true. "If I draw the things that I like, that mean something to me," she says, weighing her words carefully, "if I draw that, I believe there are plenty of people out there who will like it. I can't worry about it too much. After all, it's been working pretty well so far."

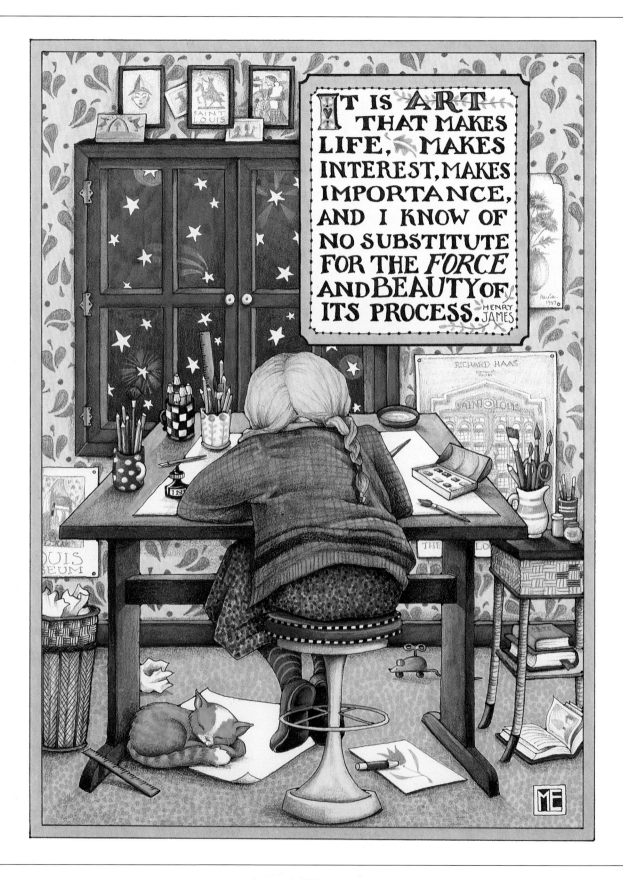

IT IS ART THAT MAKES LIFE, MAKES INTEREST, MAKES IMPORTANCE, AND I KNOW OF NO SUBSTITUTE FOR THE *FORCE* AND BEAUTY OF ITS PROCESS. HENRY JAMES

It Is Art that Makes Life

When it comes to evaluating her artwork, Mary Engelbreit is no different from her fans. She has her favorites too.

Illustrations appeal to Mary for a variety of reasons. Many of her drawings elicit memories of cherished personal experiences or of particular family members or friends. She's fond of other drawings because they represent a professional milestone—her first published greeting cards, for example, still hold extra significance to Mary.

Mary likes some drawings for their intricacy; others for their simplicity. Still other drawings appeal to her on a more technical level; perhaps the lettering came out just right or the colors worked particularly well. She is a lover of words as well as pictures, and some drawings she singles out not so much for her own

work as for the meaningful quote that it illustrates. Finally, certain drawings appeal to Mary for less tangible reasons—some drawings just *feel* right.

The collection of 82 illustrations that follows represents a sampling of Mary's personal favorite drawings. The drawings span the eighteen-year period from 1978 to 1996, and each was hand-picked by Mary for inclusion in this book. Some of these illustrations have enjoyed a life in the spotlight as best-selling greeting cards or book covers. Many others are not so well-known, but just as well-loved by the artist. Along with each drawing, Mary provides an explanation, in her own words, of why it holds a special place in her heart.

Yolanda and Her Piano, 1977
*I have no idea what this means
or who Yolanda is,
but I still like her strange little face
after all these years.*

Running Away, 1978
*This is how I feel a lot of the time,
but as you can see,
I would have to take so much stuff
with me that running away
would hardly be worth the effort.*

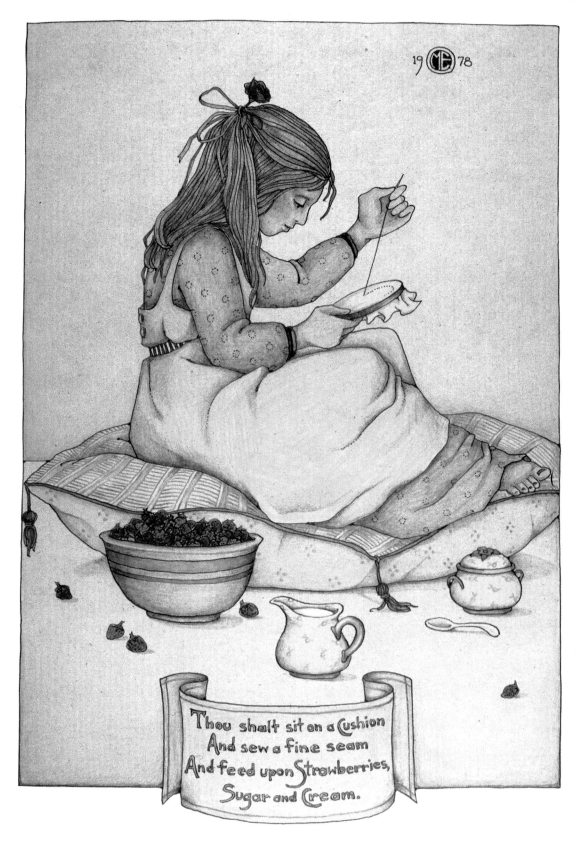

Thou shalt sit on a Cushion
And sew a fine seam
And feed upon Strawberries,
Sugar and Cream.

Strawberries, Sugar and Cream, 1978
*My friends and I used to do quite
a bit of freehand embroidery,
and I drew this during that time.
I haven't done any needlework
in years.*

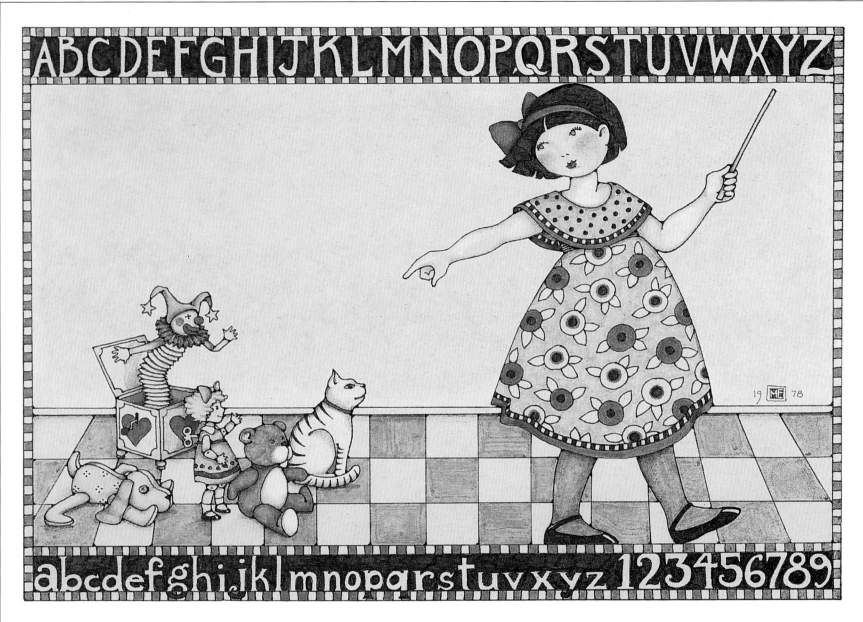

Alphabet, 1978
This was done during my 1920s period.
Notice I forgot the lower case "w"
on the bottom line.

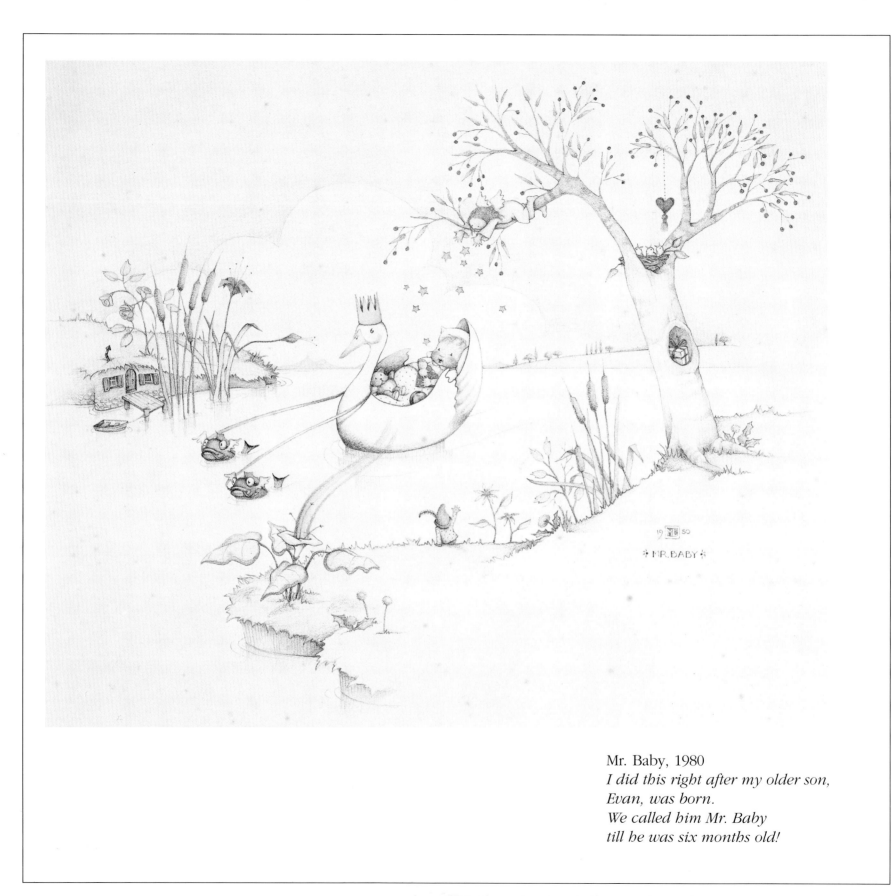

Mr. Baby, 1980
*I did this right after my older son,
Evan, was born.
We called him Mr. Baby
till he was six months old!*

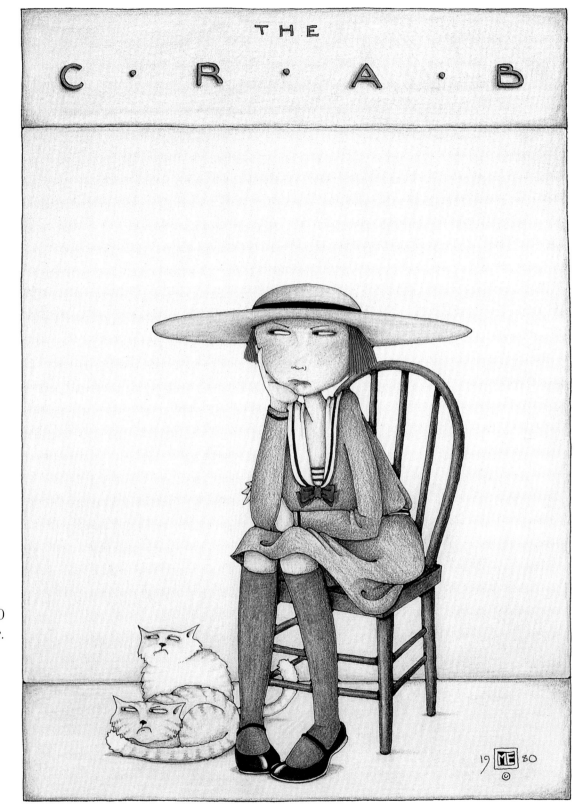

The Crab, 1980
Me.

Time Flies, 1982
*This is one of the first twelve cards
I published with my own company.
We were constantly saying this
to each other to keep ourselves going
through the first hectic months.*

The Standoff, 1982
My first cat and I had several differences of opinion. The cat usually prevailed.

THE STANDOFF

107

It is only with the heart that one can see rightly;
What is essential is invisible to the eye.
ANTOINE de SAINT EXUPÉRY

Invisible to the Eye, 1983
This quote from The Little Prince
has always been important to me.

Good Old Mom, 1983
*My mother said these exact words
to me over and over,
and I've heard from a lot of other
women that their mothers did too.
We all laughed and said we didn't
believe it, but we all hoped it was true.*

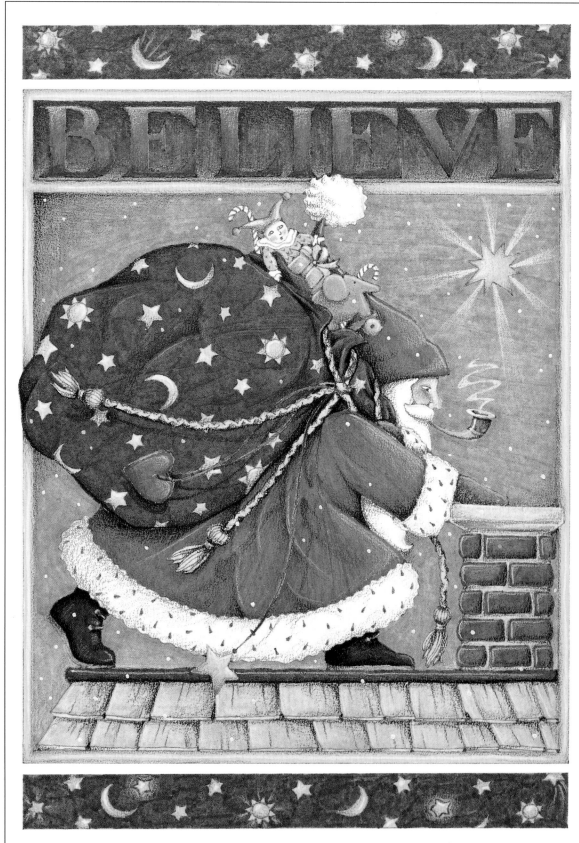

Believe, 1983
This is one of my most popular drawings ever. I drew another version of "Believe" because I was getting a little tired of this one, but apparently no one else is!

The New Associate, 1983
My view of motherhood.

Here, 1983
*This is another one of the first cards
my own company produced.
Thirteen years later,
it's still a top seller.*

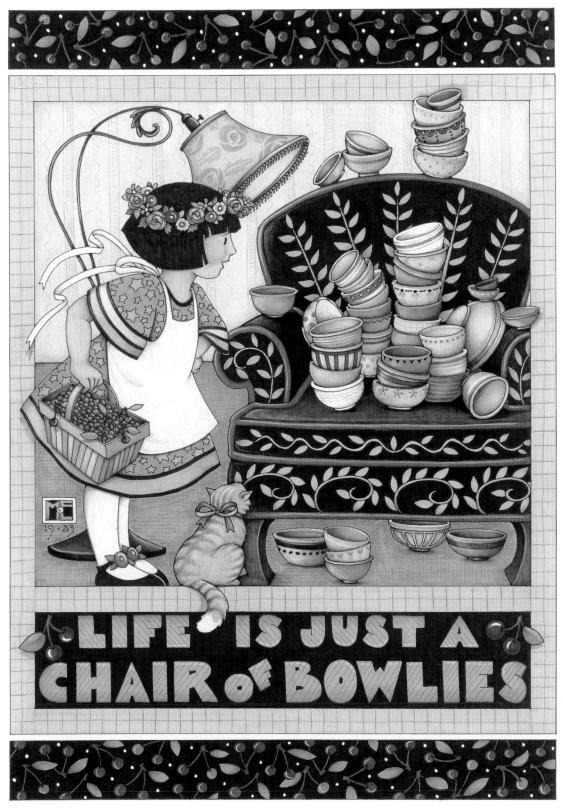

Life Is Just a Chair of Bowlies, 1983
I think everyone knows this story by now. The old beau involved says I have it wrong, but now it's my story, and I'm sticking with it.

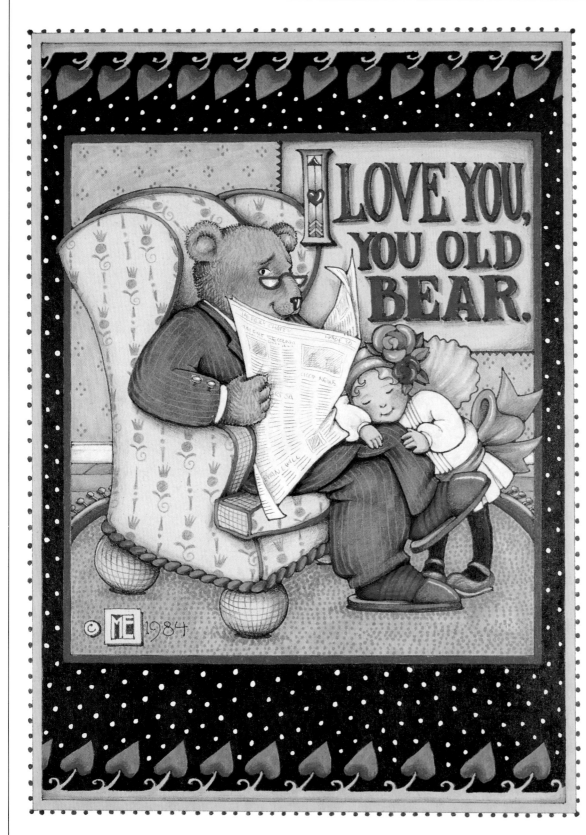

I Love You, You Old Bear, 1984
*I did this one for my father,
who <u>was</u> a lovable old bear.*

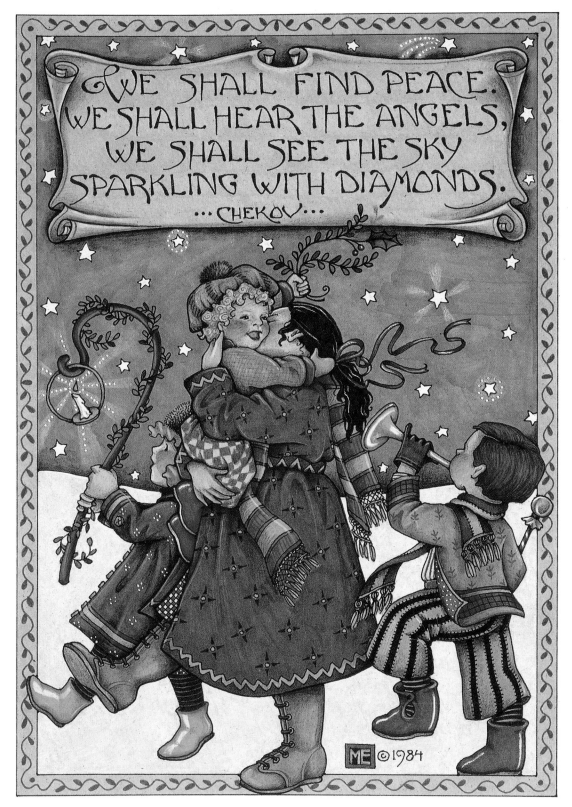

Sparkling with Diamonds, 1984
I really like this drawing;
I think because it expresses
the spirit of Christmas
without being blatantly Christmasy.
And of course,
the quote is just beautiful.

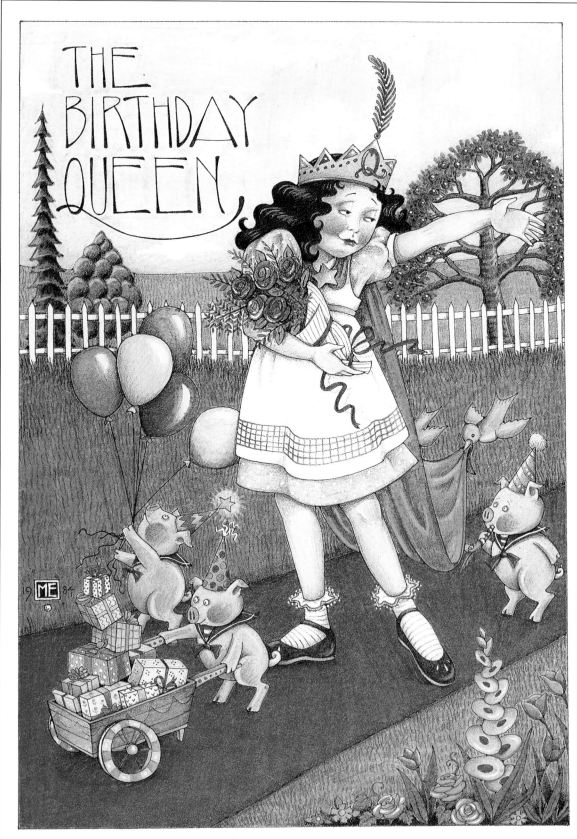

The Birthday Queen, 1984
*As my friends will tell you,
this is exactly how I feel
about my birthday!
I definitely believe in celebrating
all the events, big or small,
in our lives!*

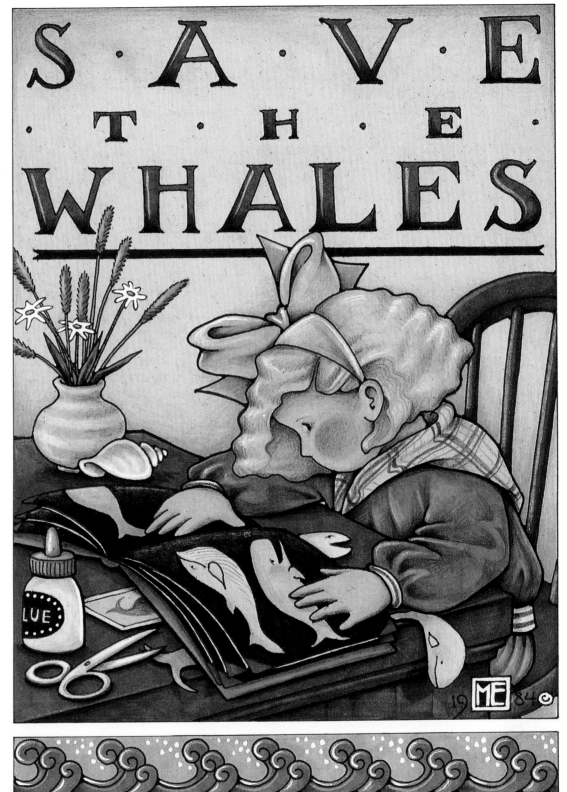

Save the Whales, 1984
I hope we're not really reduced to saving the whales in this fashion. I did this for a very ecologically-minded friend of mine in exchange for a beautiful woven blanket that she made.

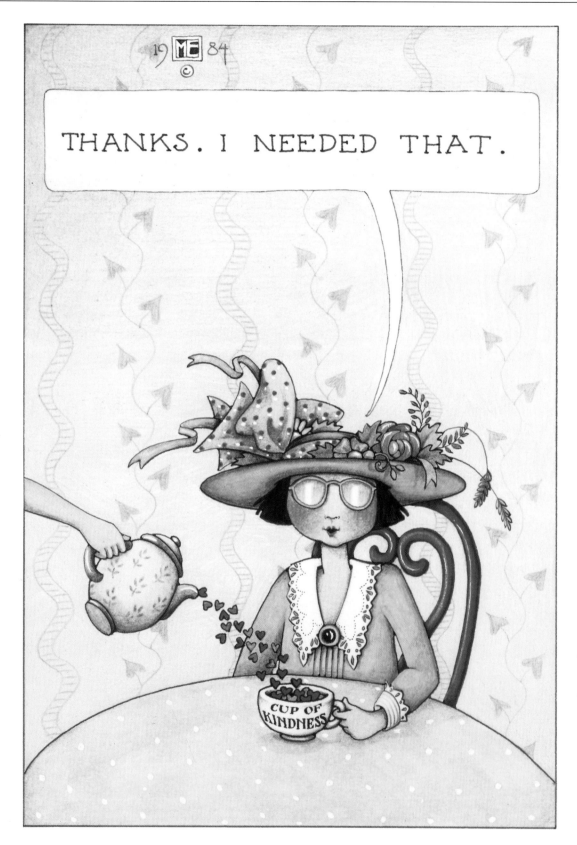

Thanks. I Needed That., 1984
*Although I know most people prefer
the busier drawings,
I really like these simple,
more graphic compositions.*

A Book Is a Present, 1985
*This was a poster for my beloved
Left Bank Bookstore, where I've had
my shows for so many years.
The saying is by one of the dedicated
owners, Barry Leibman.*

Don't Look Back, 1985
I drew this at a time
when we were making big changes
in our business. Luckily,
they all seem to have worked out.

Better Not Pout, 1986
This is how I feel after doing ten
Christmas cards by the middle of July.

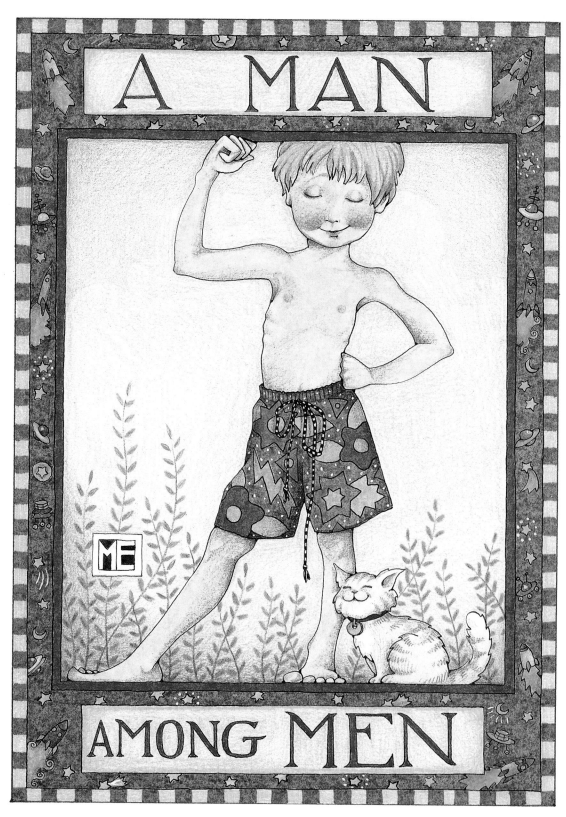

A Man Among Men, 1986
This is a picture of my older son at the beach. He modeled for me between swims.

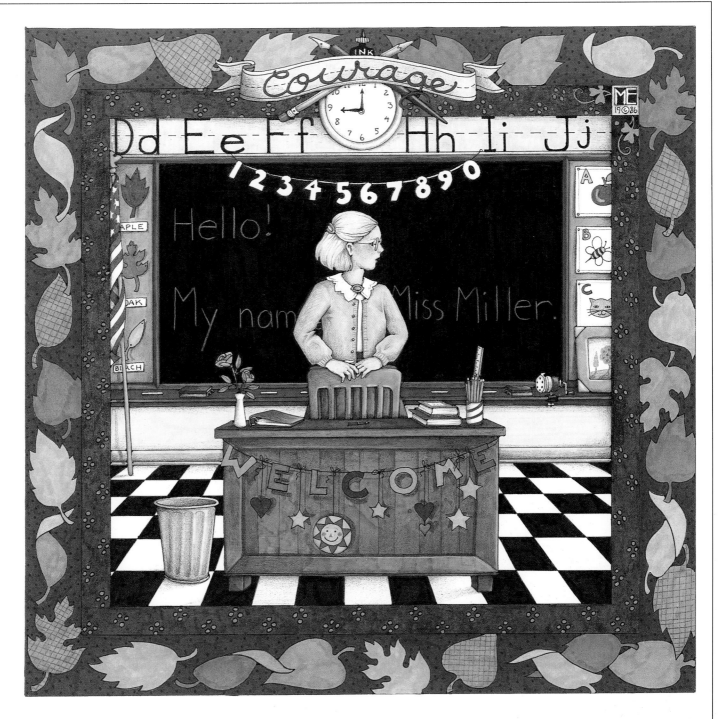

Courage, 1986
*I imagined a new teacher on her first
day, hearing all that noise
out in the hall and wondering,
"What have I <u>done</u>?"*

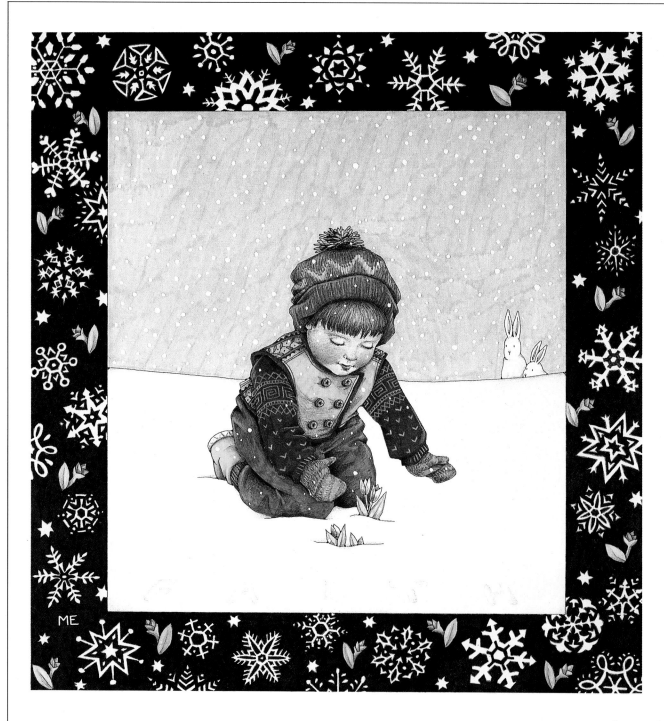

Faith, 1986
I like the simplicity of this drawing.
It was inspired by my younger son,
Will's, fascination upon seeing his first
crocus peeking through the snow.

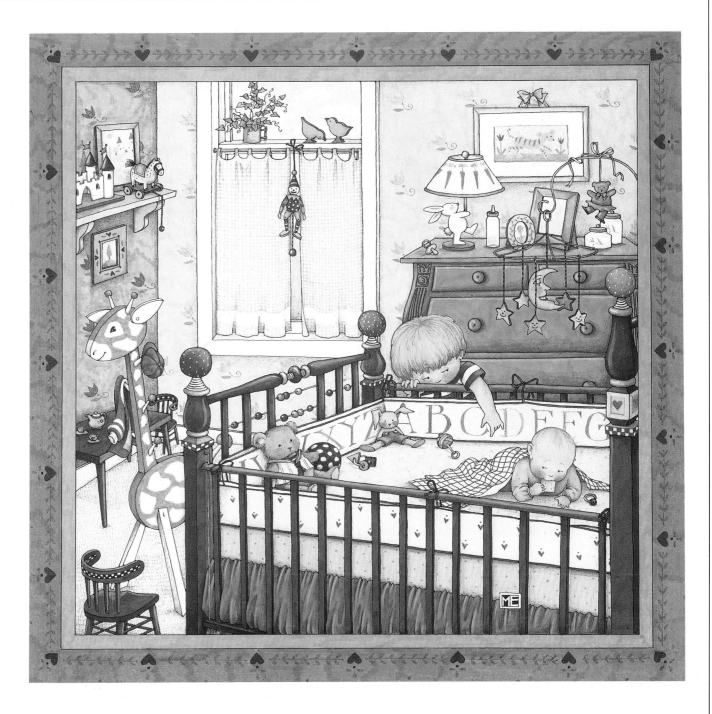

New Baby, 1987
*Obviously I drew this after
my second son was born.
Evan had mixed feelings about our
newest addition.*

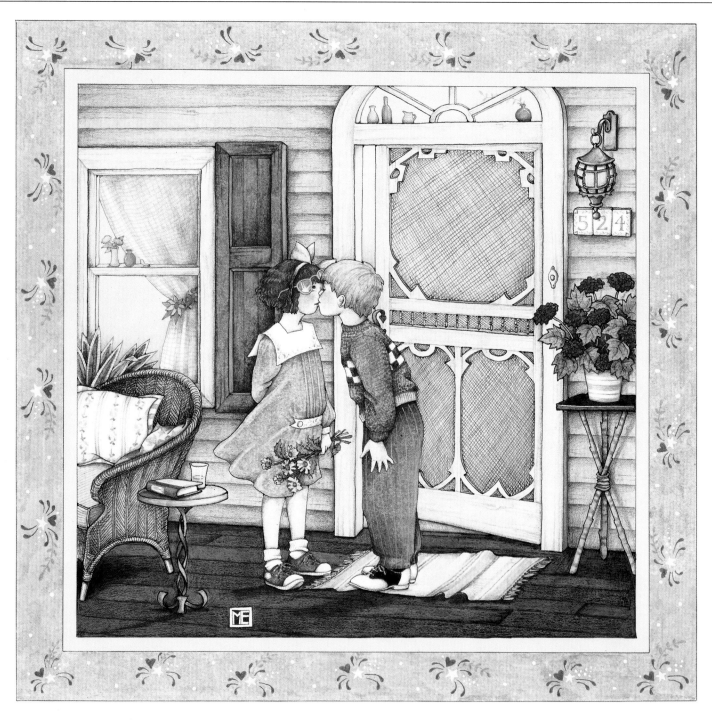

First Kiss, 1987
This is the front porch of the house we lived in when both of our sons were little. I don't know who these kids are, but I know just how she feels!

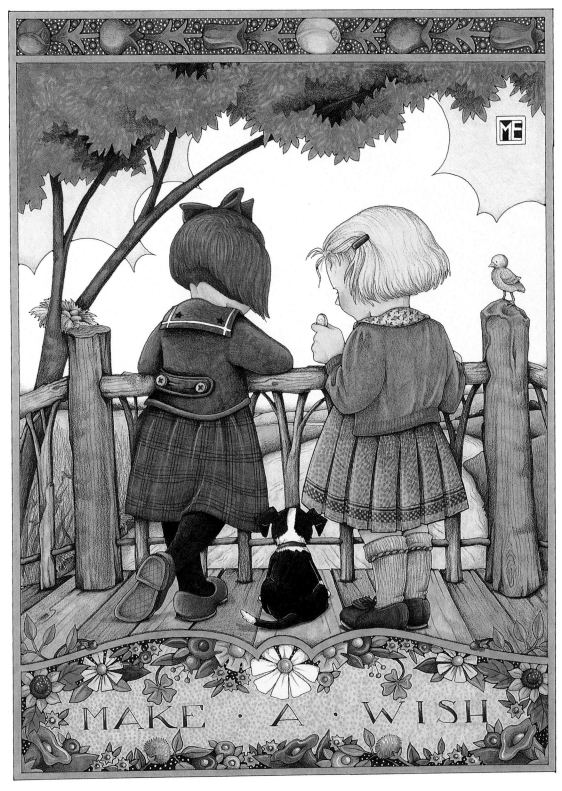

Make a Wish, 1987
I drew this right after we got our dog,
Rosie. She was so cute that I had to put
her in a picture!

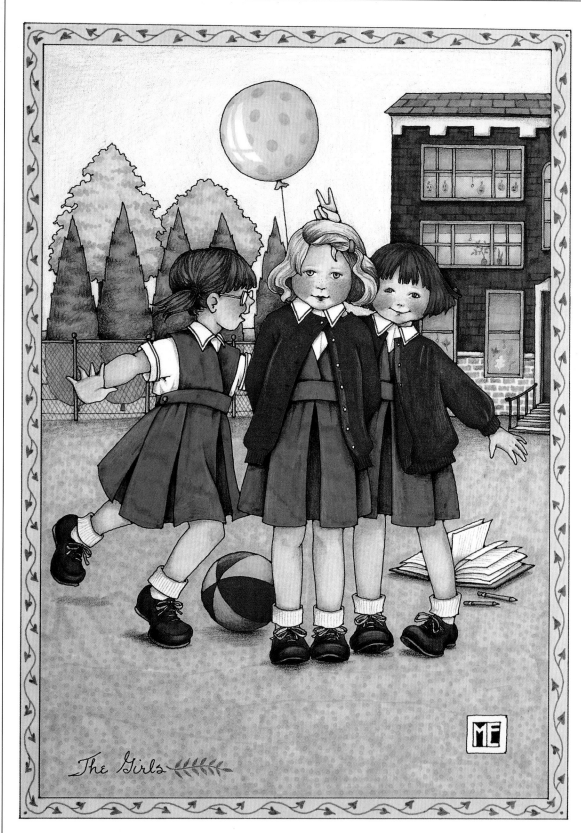

The Girls, 1987
*The little girl in the center is one
of my oldest friends.
I am now godmother to her daughter.
Time flies!*

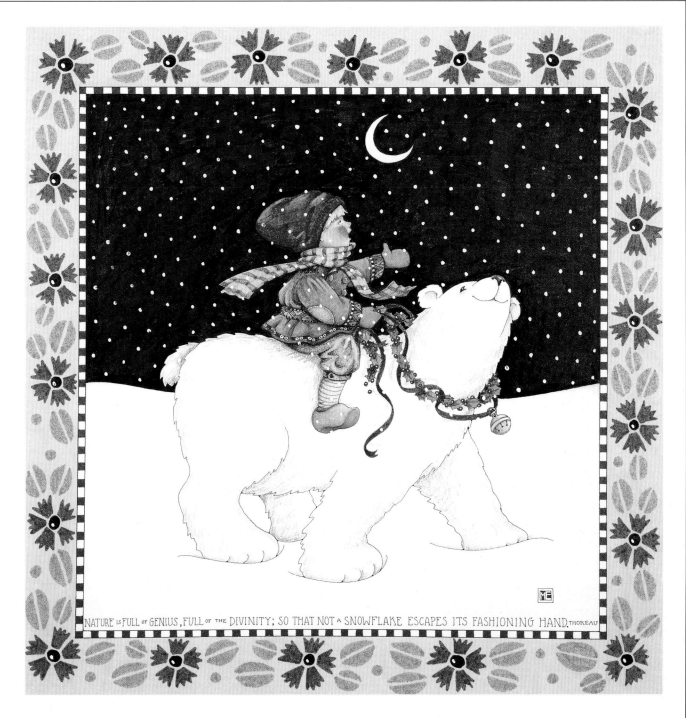

Nature is Full of Genius, 1988
*One of my un-Christmas
Christmas cards.*

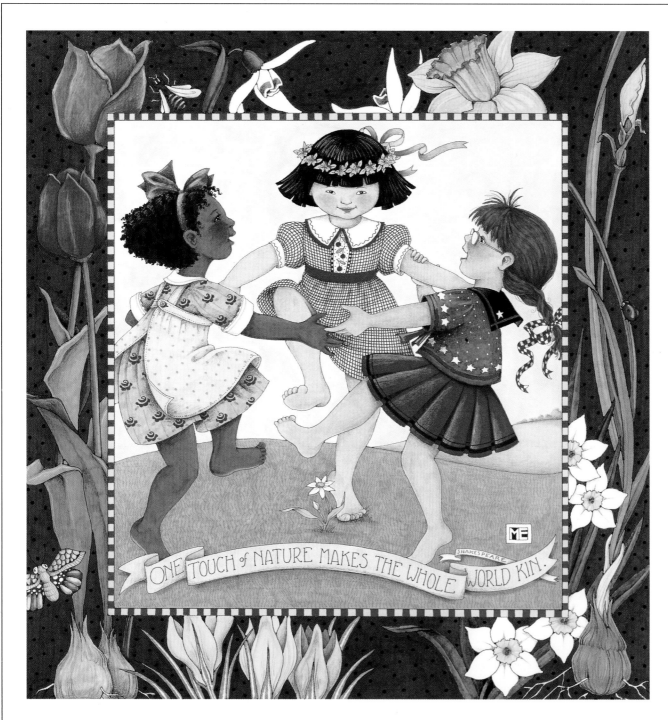

ONE TOUCH of NATURE MAKES THE WHOLE WORLD KIN.
SHAKESPEARE

One Touch of Nature, 1988
The border on this drawing is much different from what I usually do, but I really enjoyed doing a little research and making the flowers look real for a change.

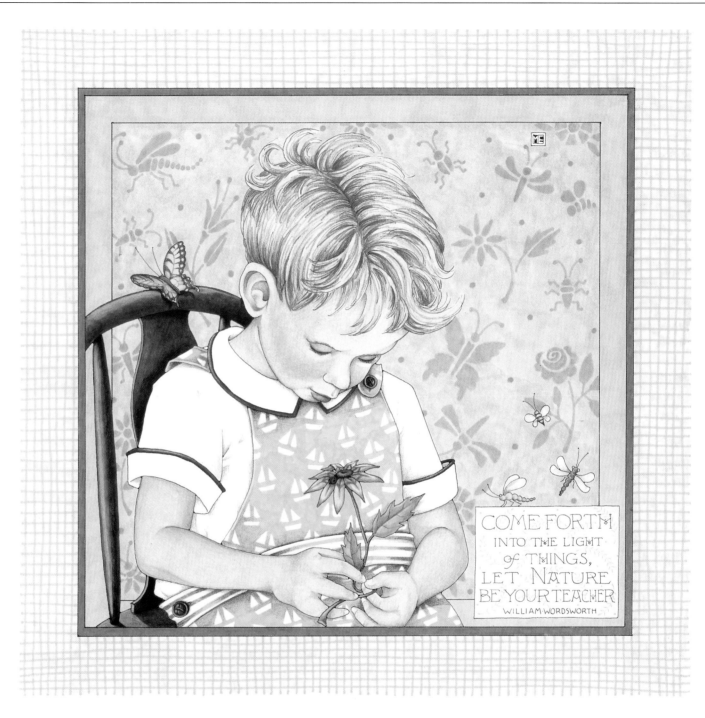

Let Nature Be Your Teacher, 1988
I'm fascinated by how beautiful insects are, and it was fun to be able to incorporate them into a drawing.

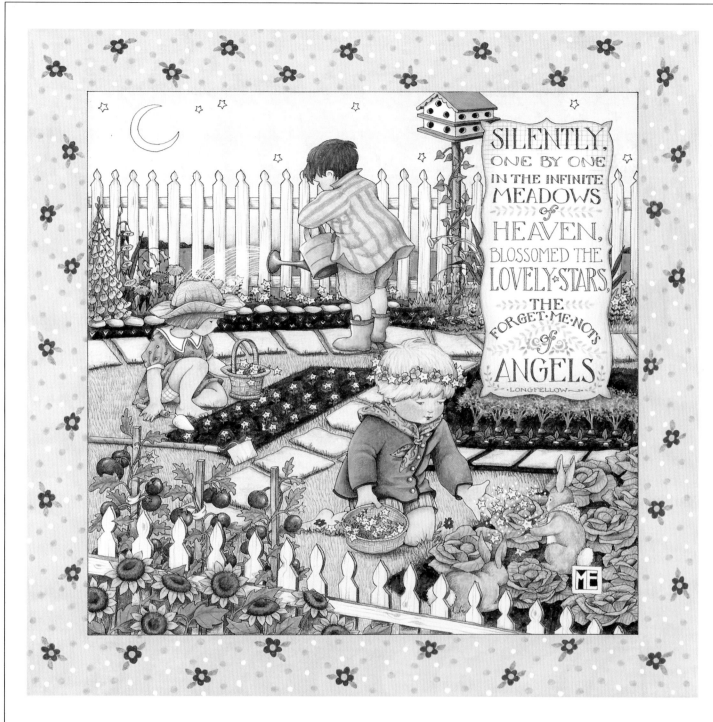

The Forget-Me-Nots of Angels, 1988
What a beautiful quote!
This is the only way I garden—
in pen and ink.

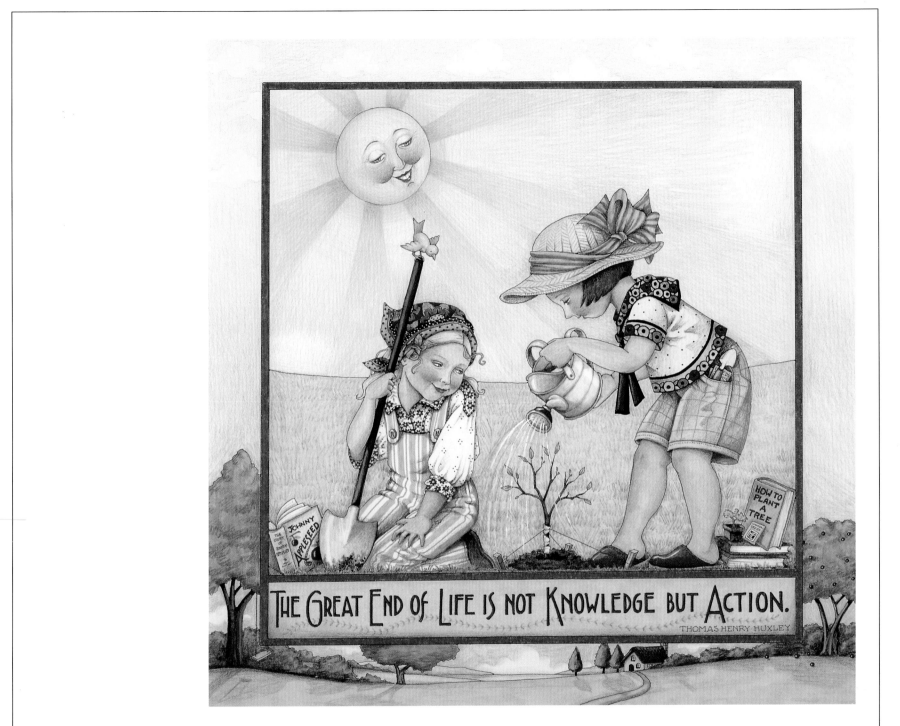

THE GREAT END OF LIFE IS NOT KNOWLEDGE BUT ACTION.

THOMAS HENRY HUXLEY

The Great End of Life, 1988
I very much believe in this quote.
It does no good to think or talk
or wish without the action
to back it up.

Snap Out of It, 1988
This is what I felt that day so this is what I drew that day. It's one of our best-sellers!

Hide 'n Seek, 1989
*This was the cover for a nature-themed
calendar.
I am proud to be a "tree-hugger"!*

Wicked Witch, 1989
*I like to keep Halloween fun,
not scary.*

Oh, No, 1989
*Wouldn't you feel this way
if you realized you had forgotten
a good friend's birthday?
I did!*

It's Good to Be Queen, 1989
King, schming.

...It is not a slight thing when they, who are so fresh from God, love us.

·DICKENS·

Fresh from God, 1989
This quote is so wonderful—
it was very easy to illustrate!

'D LIKE TO BE THE SORT of FRIEND THAT YOU HAVE BEEN TO ME
I'D LIKE TO BE THE HELP THAT YOU'VE BEEN ALWAYS GLAD TO BE;
I'D LIKE TO MEAN AS MUCH TO YOU EACH MINUTE OF THE DAY
AS YOU HAVE MEANT, OLD FRIEND of MINE, TO ME ALONG THE WAY
·EDGAR A. GUEST·

Old Friend of Mine, 1990
This one is for all my wonderful friends.

A Real Boy, 1990
*I drew this for my son, Evan.
I try to draw "boy cards" that my sons
would not be embarrassed to receive,
but it's hard.*

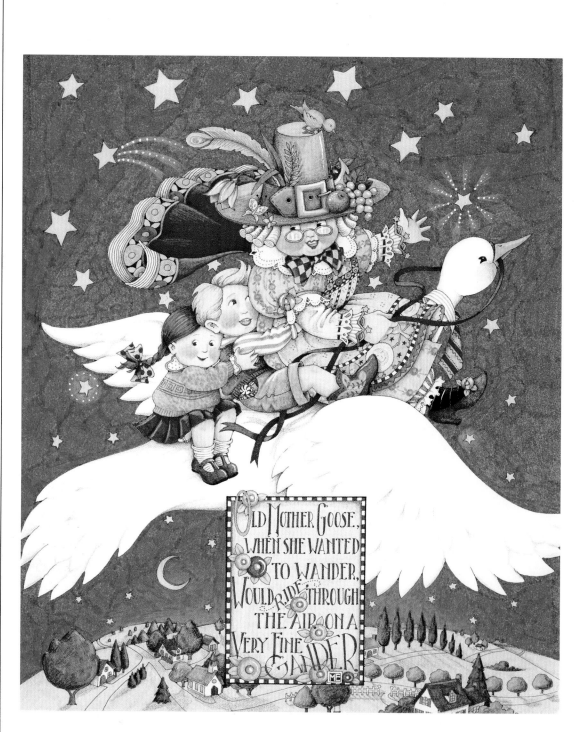

OLD MOTHER GOOSE,
WHEN SHE WANTED
TO WANDER,
WOULD RIDE THROUGH
THE AIR ON A
VERY FINE GANDER

Old Mother Goose, 1990
*I had always wanted to illustrate
Mother Goose. I was pretty happy
with the way this came out.*

Holiday Tea, 1991
*I had a lot of fun with this because
I got to draw some of my favorite
things in our wonderful Saint Louis
Art Museum.
All proceeds from this card
benefit the museum.*

Mystical Magical Toyland, 1991
This is one of my favorites.
I really like alphabet pictures
for some reason,
and I am really fond of that monkey!

At the Seaside, 1991
Don't you wish these swimming suits
were actually in vogue?
This is another ode to our idyllic days
on the beach.

The Good List, 1991
*Because all the names on the list
are friends and family members,
this drawing was very fun to do,
although I was panic-stricken
that I had left somebody out!
Now, of course, I have hundreds of
new names I'd like to add to the list.*

A Little House, 1991
*I love houses and couldn't wait
to have one of my own.
I think a house says so much
about the people who live there.
They're a source of endless
fascination to me.*

Blessings, 1991
This is one of my favorite calendar covers.

Wild West, 1991
When I visited out west,
I used to buy all this great-looking
Western stuff.
Then I'd get it home to St. Louis and
think "What was I thinking?"
But here is a picture of me if I were to
wear all of my purchases at once.

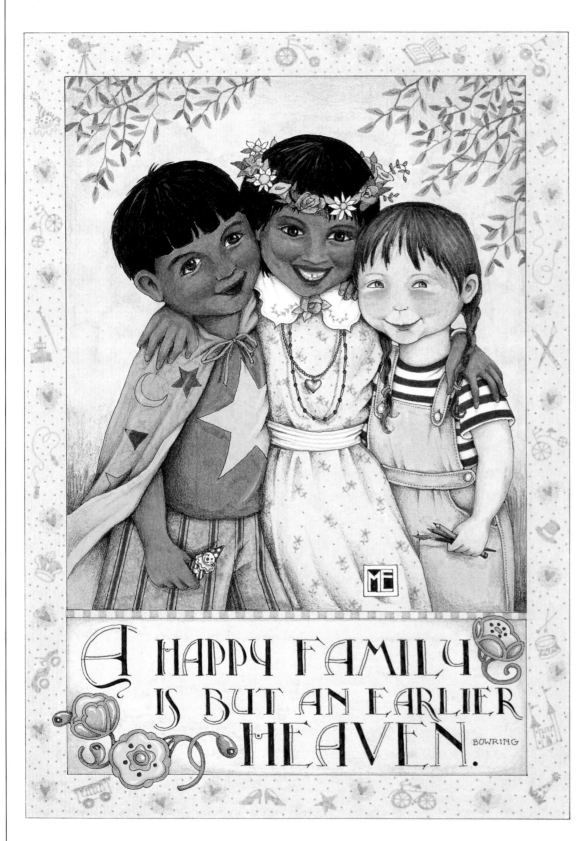

A HAPPY FAMILY IS BUT AN EARLIER HEAVEN.

BOWRING

A.J., Karla and Anna, 1991
*For the auction at my sons'
elementary school I would offer
the opportunity to have your kids
put into one of my drawings.
This darling family
was one of my favorites to do.*

150

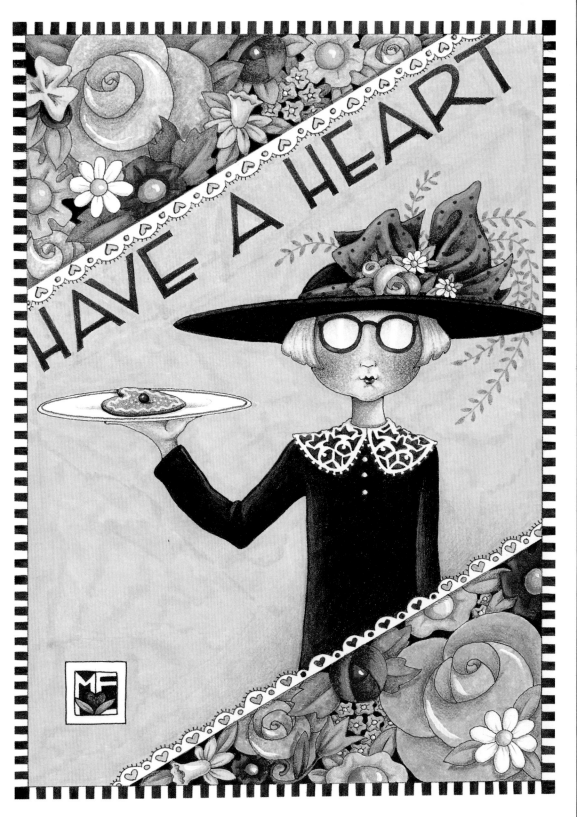

Have a Heart, 1992
I feel a little awkward getting too mushy with drawings about love, so they usually come out looking like this.

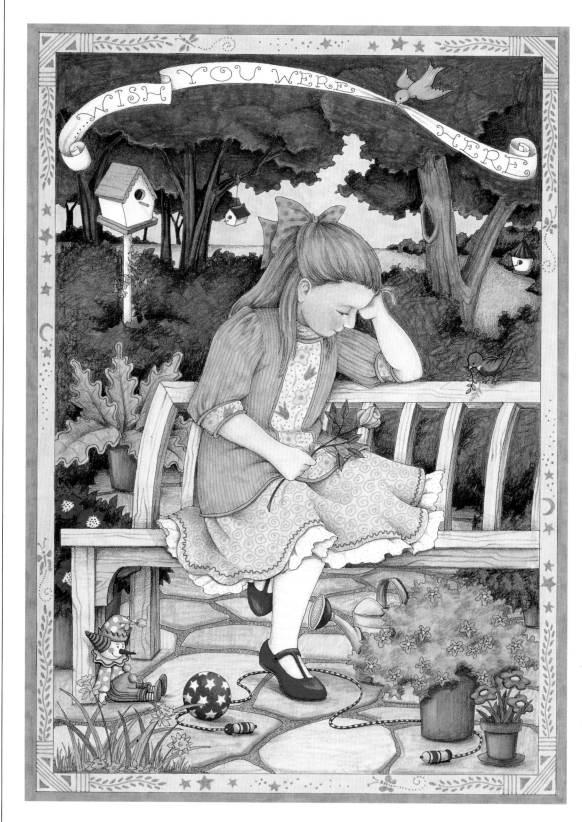

Wish You Were Here, 1992
*I really like inventing clothes like this
for my characters to wear.
You know they'd be hideous
in real life, but they're perfect in the
pictures!*

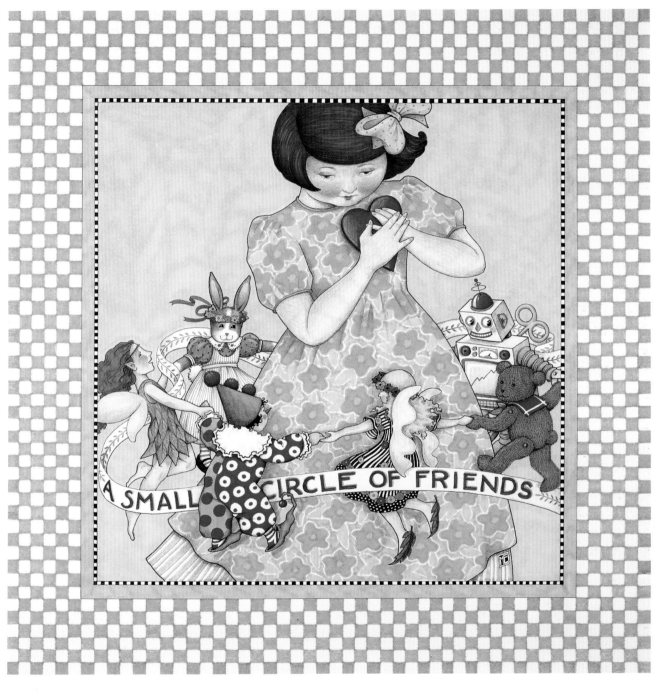

Circle of Friends, 1992
*I had done another drawing like this
earlier but had never been happy with
it. I like this one much better.
Practice makes perfect,
or as close to it as I'm going to get.*

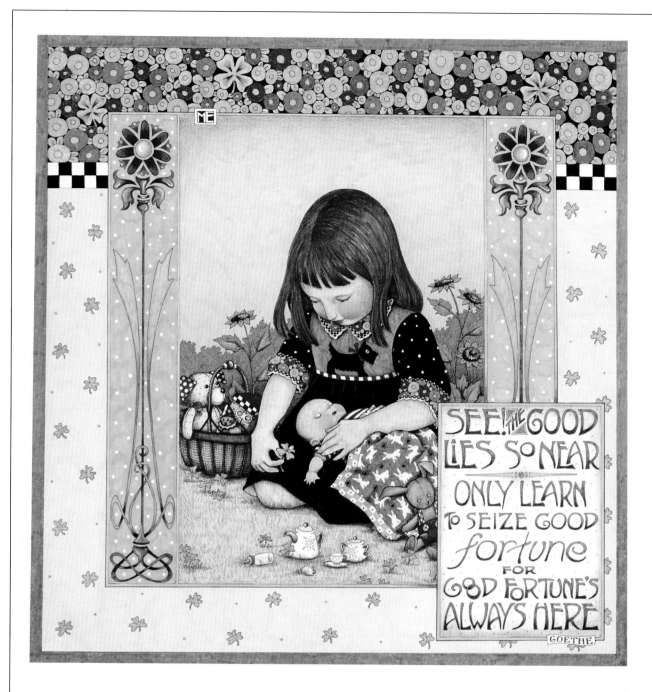

SEE! THE GOOD LIES SO NEAR ONLY LEARN TO SEIZE GOOD fortune FOR GOOD FORTUNE'S ALWAYS HERE
GOETHE

See the Good, 1992
In the calendar in which this drawing appeared, I tried to get away from doing square formats with a one-inch border, as I had always done before. Every border was different and included an "art-noveau-y" mix of patterns.

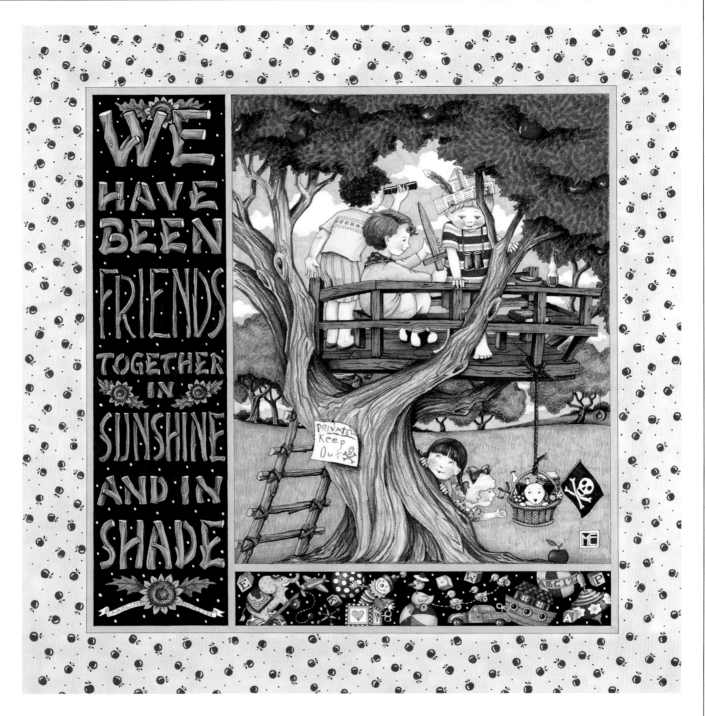

We Have Been Friends, 1992
*My sons loved playing in their tree-
house. I just wish our backyard was
really this expansive.*

Cover: Gardener's Journal, 1992
*I collect old books, and I really enjoy
doing my book covers in that
old-fashioned style.*

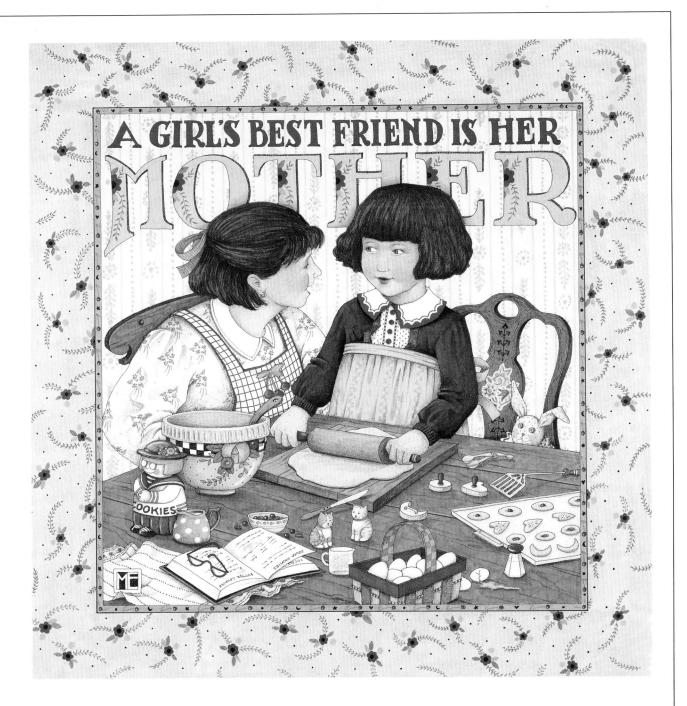

A Girl's Best Friend, 1992
This is certainly how I feel about my mother. I have many fond memories of baking in our kitchen, although in our case, it was almost always pies, and I was almost always just watching and eating dough.

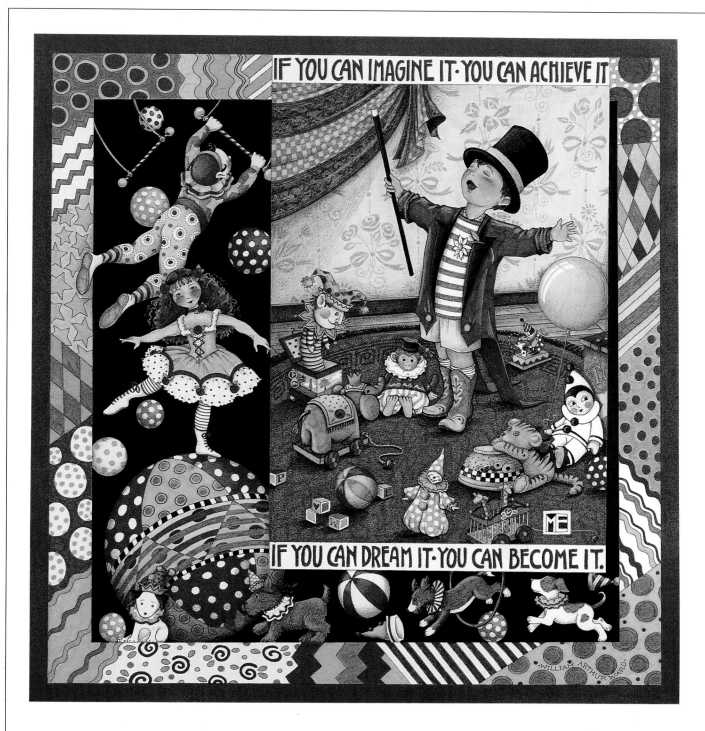

If You Can Imagine It, 1992
This is one of my favorite drawings and a quote that I am constantly trying to drill into my kids' heads.

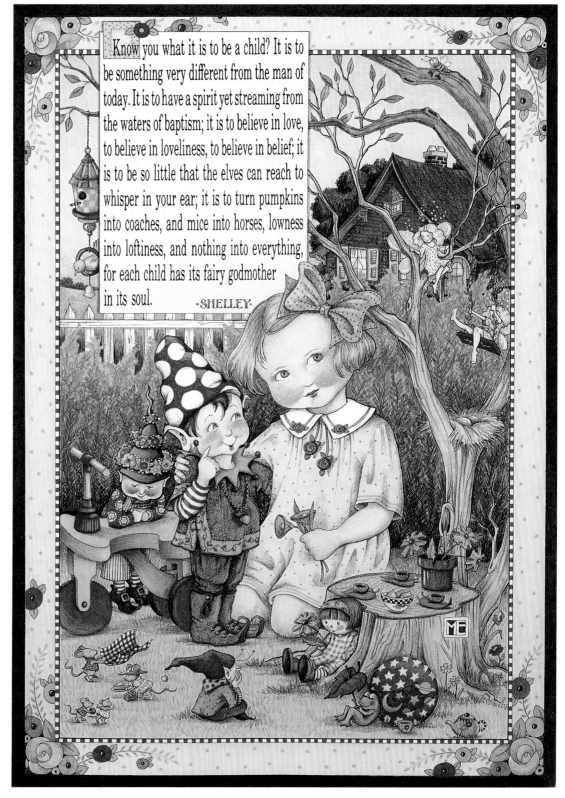

Know you what it is to be a child? It is to be something very different from the man of today. It is to have a spirit yet streaming from the waters of baptism; it is to believe in love, to believe in loveliness, to believe in belief; it is to be so little that the elves can reach to whisper in your ear; it is to turn pumpkins into coaches, and mice into horses, lowness into loftiness, and nothing into everything, for each child has its fairy godmother in its soul.

·SHELLEY·

What It Is to Be a Child, 1992
I did this for my goddaughter on the occasion of her christening. This is one of my all-time favorite quotes.

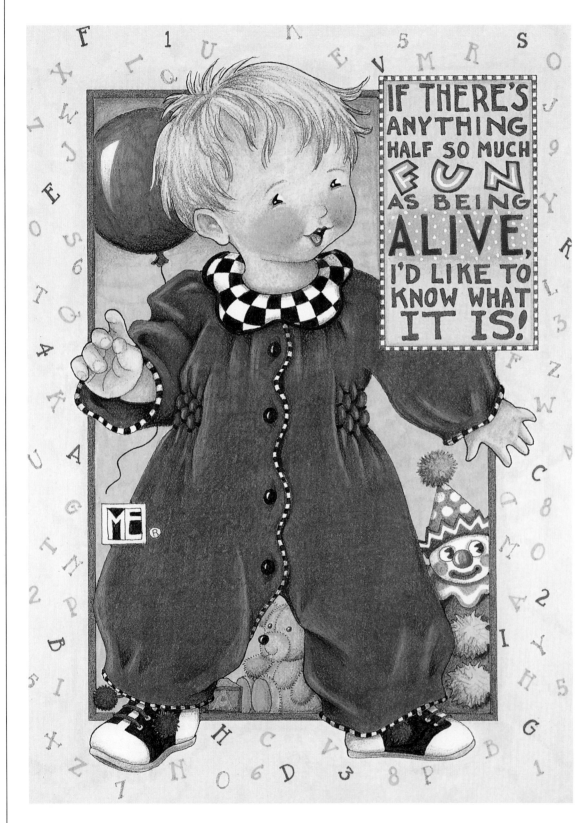

IF THERE'S
ANYTHING
HALF SO MUCH
FUN
AS BEING
ALIVE,
I'D LIKE TO
KNOW WHAT
IT IS!

Alive, 1993
This is a celebration of the joy most
children seem to get out of life
with so little effort!

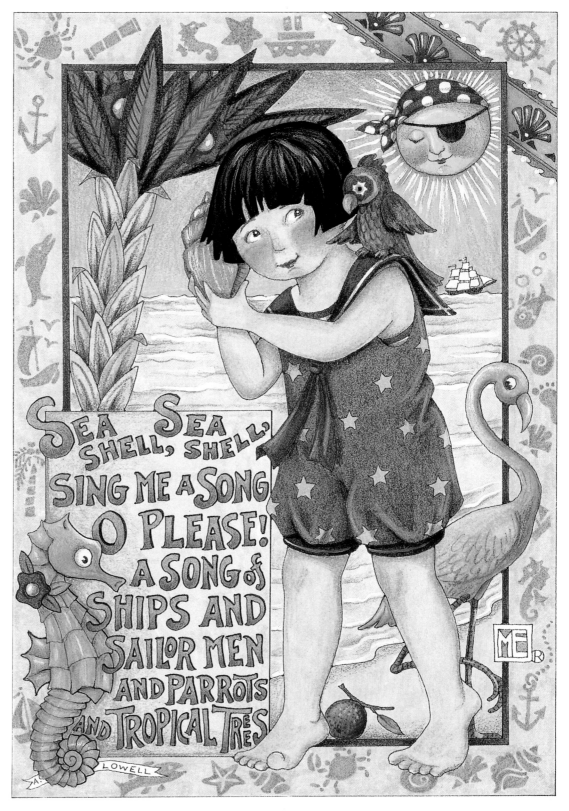

Sea Shells, 1993
Another beach-inspired drawing.

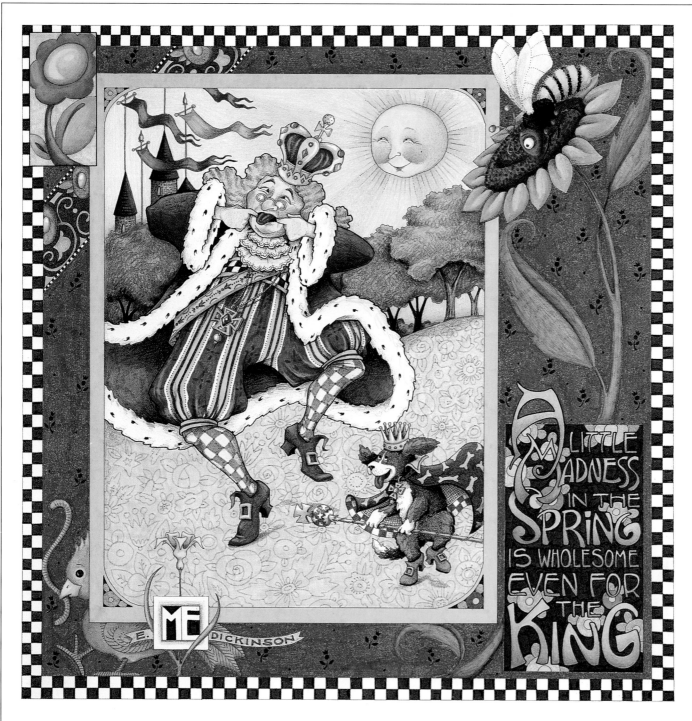

A Little Madness, 1993
*This calendar was particularly fun to
do because the borders were
all different and asymmetrical;
I felt this made for much more
interesting pictures.*

162

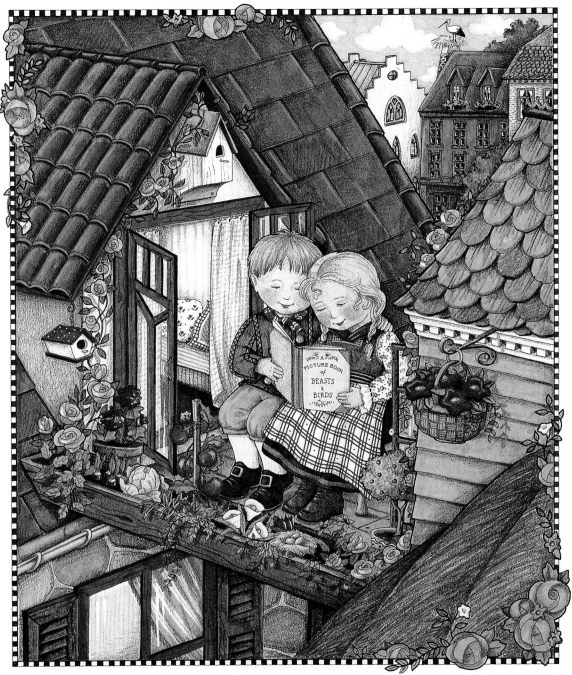

A Little Boy and a Little Girl, 1993
A drawing near and dear to my heart—the first illustration for The Snow Queen. *It's very similar to one I did a long time ago. Since the first time I read the story as a little girl, this is how I pictured this scene.*

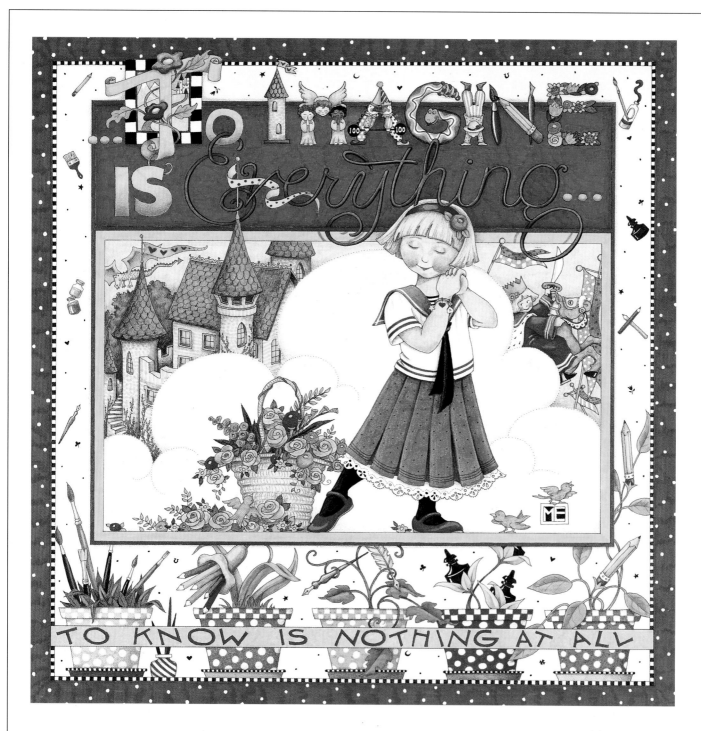

To Imagine Is Everything, 1993
To me, imagining things is almost as much fun, if not more fun, than the real thing.

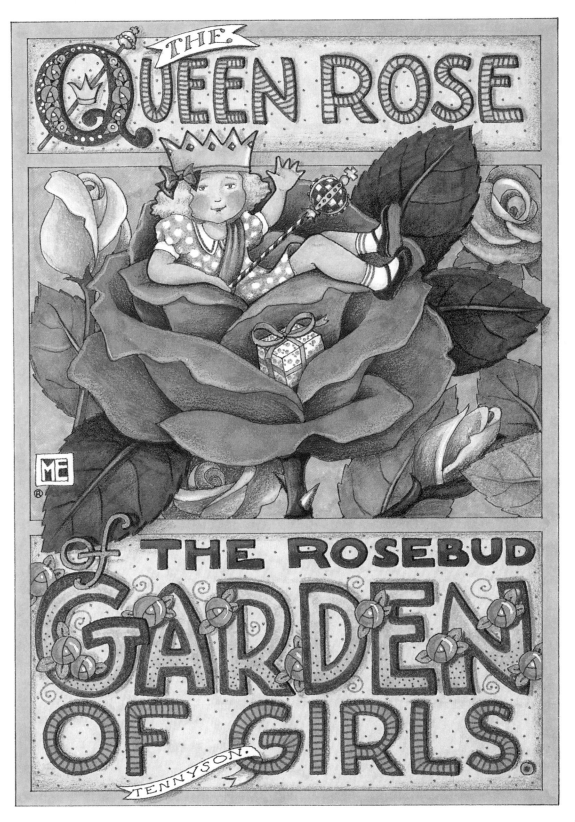

The Queen Rose, 1994
I thought this was the sweetest quote.
When I am really enthused about a
quote, I think the drawing usually
turns out pretty well.

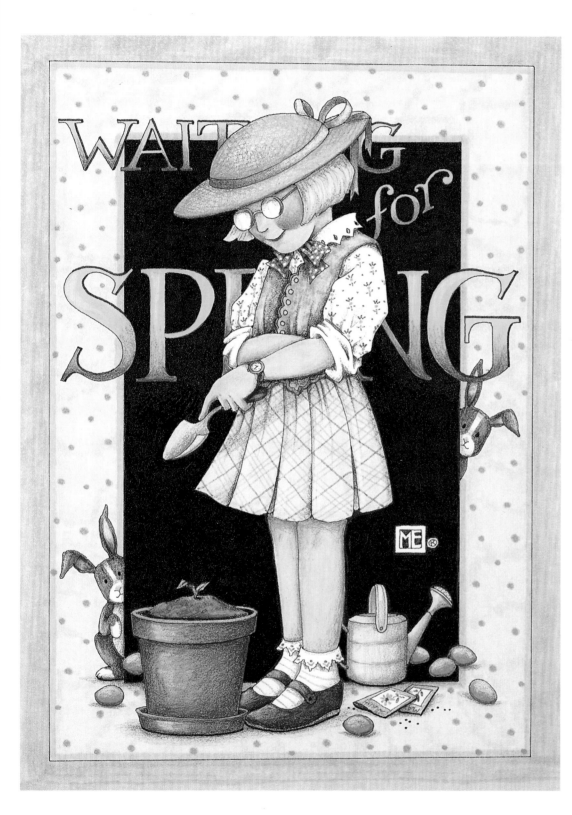

Waiting for Spring, 1994
This is based on a painting by Maxfield Parrish, one of my favorite illustrators. I like the way things stand out against a black background.

Real Life Calendar Cover, 1994
*Anyone who says parenting is a breeze
is lying, but there are moments
that make it all worthwhile.*

A HAPPY FAMILY IS HEAVEN ON EARTH

Heaven on Earth, 1994
Times like this may be few and far between in real families, but they do happen, and I like to preserve them in my drawings.

Castles in the Air, 1994
*This was inspired by our many trips to
the beautiful Gulf Coast of Florida.
I could spend hours watching my
children play on the beach and help-
ing them build sand castles and forts.*

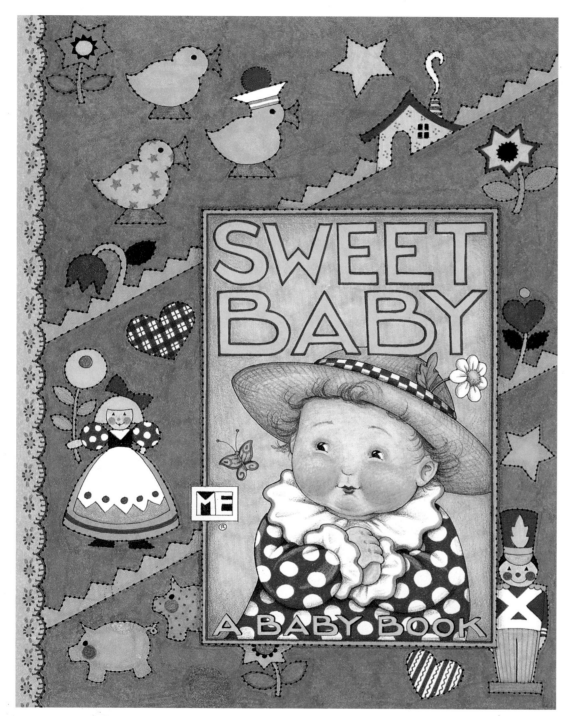

Sweet Baby, 1995
*This was the cover for a baby book
that was never published, although
I did turn it into a card.
We try to let nothing go to waste.*

All Hail, 1995
I'm a firm believer in gaudy, loud, lots-of-gifts-and-cake celebrations for everyone's birthday!

Dysfunctional, 1995
Good advice, I think.
You may as well go with the flow!

Loving Hands at Home, 1994
*This was based on the cover of an old
1920s coloring book I had at home.
I like its clean graphic look.*

Cover: Homeowner's Journal, 1995
*Why don't they make houses
like this anymore?*

Cover: Wedding Journal, 1995
*I have had truly dismal luck drawing
brides in the past, so I decided to skip
her altogether and go for the cute
attendants, who are more my style.*

Lives. Get One, 1995
*What can I say? Apparently
I was annoyed about something.*

We Don't Care, 1995
Just teasing our wonderful friends in New York a little—letting them know there is life outside the Big Apple. (What does that mean—the Big Apple?)

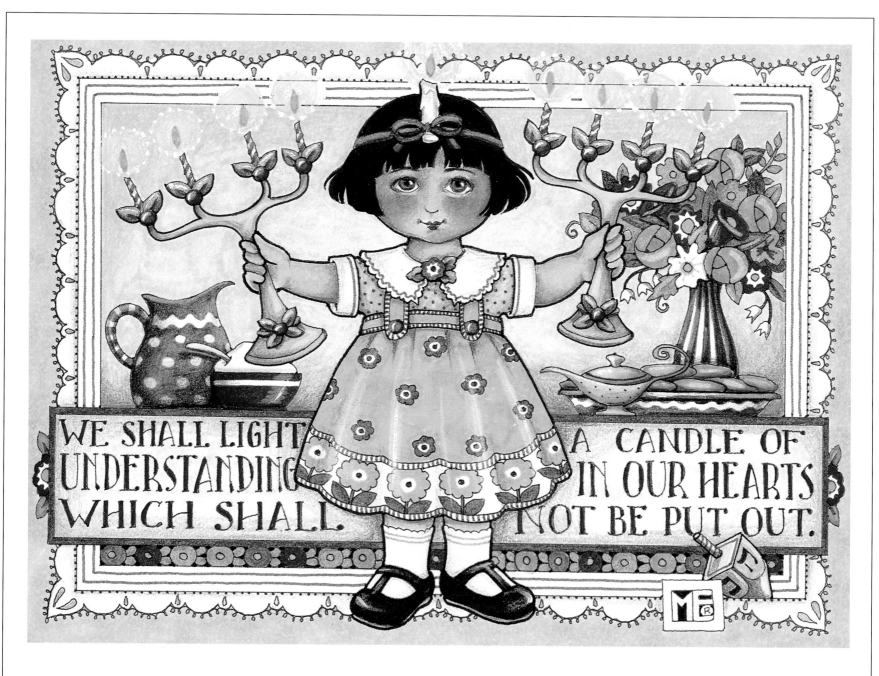

Light a Candle, 1995
*It was interesting to research
the traditions, foods, songs,
even the colors for this Hanukkah card.*

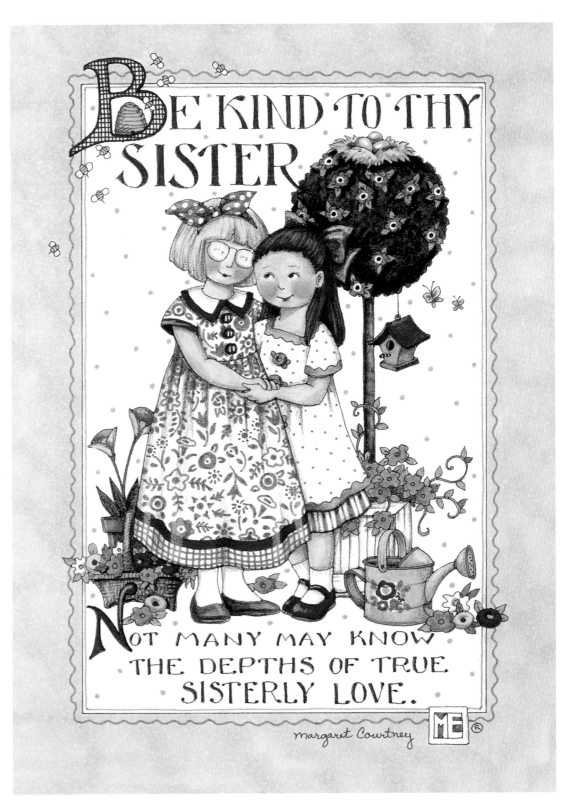

Be Kind to Thy Sister, 1995
Me and Alexa! For Alexa's birthday.

179

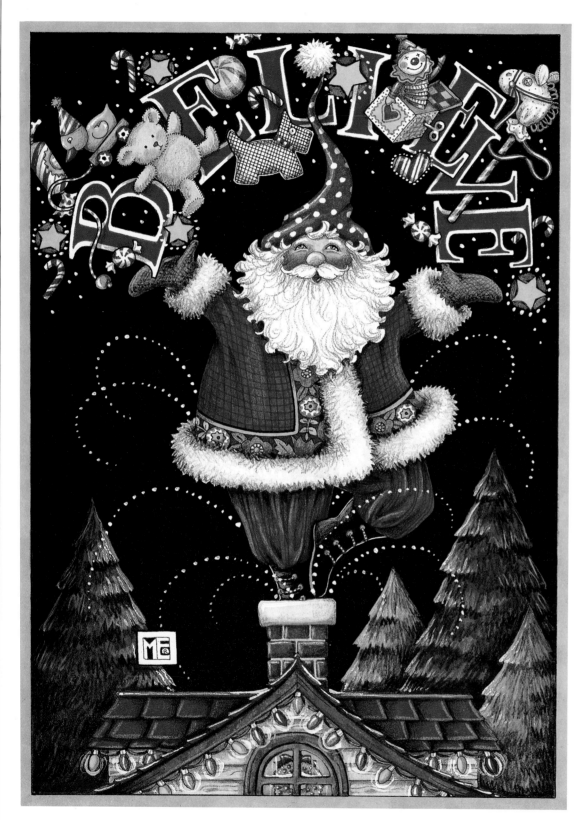

Believe II, 1996
I needed a break from the original
"Believe" card. We have yet to see if
this one will be as successful.